IMAGES
of America

BILLERICA

A STATEMENT OF THE EXPENSES OF
THE TOWN OF BILLERICA.

FROM APRIL 1, 1833, TO APRIL 1, 1834.

SCHOOL EXPENSES.

For Schools,	$1000 00

PARISH EXPENSES.

To Rev. Mr. Whitman's Salary,	$700 00
" T. Shed, taking care of Meeting-house and ringing bell one year,	7 00
" Repairing M. house door,	25
" Oil for clock, 38 ; taking down stoves and putting them up,	1 00
For sweeping Meeting-house.	4 50
To M. Wheeler repairing M. H. bell,	1 50
" Tho. Shed repairing glass to Meet-house at various times,	3 84
" G. Saunders for sawing wood at M. house,	33
" T. Shed, paid for stove-pipe, &c	4 00
" Wm. C. Parker, building fires in M. H. for the years 1833 and 1834,	17 33
" W. Whitfield for wood for M. H.	4 25
Collector's Commissions	14 75
	$758 75

Expenses of Bridges, Roads, &c.

To Jos. Kendall, 2 stringers for logging bridge, 100 feet plank, labor and ox work	12 40
" G. Parker, work on middle bridge	32 05
" J. & H. Baldwin, teaming lumber from Canal Mills to Middle Bridge, 2 00 ; J. Wright for labor on same, 1 50 ; teaming, &c. 2 00 ; 1753 ft. plank and joist for do. 24 54 ; paid Churchill for labor on same, 27 00 ; Patten for 711 ft. plank, 8,53; teaming same, 1 50 ; J. Litchfield for labor and board 7 days, 8 75 ; refreshment for workman 4 50 ; damage to J. Wright's rope, 1 00	81 32
" J. Baldwin's services as Committee on rail-road and chaise hire	1 25
" S. Parker, labor on Middle Bridge	3 75
" Mrs. Sprake for gravel and work on road	7 11
" Josiah Rogers, paid for plank and stringers for Shawsheen bridge and labor, &c.	14 18
" Service as rail-road committe-man	2 00
" J. Stevens, services as committee man against O. M. Whipple's petition, horse and chaise hire	5 25
" J. B. Richardson, repairing bridge, 83 ; paid various individuals for labor and his own work repairing corner bridge	11 73
Do. time spent as committee on Stevens' road, 2 00 ; paid Wm. C. Jarvis, Esq. as counsel, 5 50 ; two days on Whipple's road, 4 00	11 50
To Daniel Wilson, 2184 feet stringers for M. Bridge	30 58
" T. Davis, waiting on county commissioners 3 times on Stevens' petition	3 50
" M. Preston, 1 day viewing roads on Locke's petition, 2 00 ; attending court and arguing the same, 5 ; service as committee-man on rail-road damages, 3 00 ; do. two days on O. M. Whipple's petition, and arguing against the same at court, 5 00	15 00
" M. Crosby, attendance on town com's on Locke's petition, 1 day	1 00
" N. Stearns, plank for corner bridge, 37 14 ; timber for middle bridge, 59 62 ; plank for M. bridge, 6 50 ; do. for canal mills bridge, 4 36	107 62
" Sarah Sprake, gravel for road	3 72
Had from town farm, work and timber for corner bridge	6 00
To J. Baldwin, attending county commissioners two days and expenses on Whipple's petition	2 00
" Horse and chaise 18 ms. same time	3 00
" Use of team for middle bridge	1 00
Paid for survey of roads, plan, chainmen and expenses	19 45
	$375 41

Expenses of Town Officers, &c.

To Philip B. Dow for entertainment for assessors	3 25
" M. Preston, time spent at Boston with rail-road agents to settle damages and paying town farm notes at Charlestown, 1 00 ; taking invoice of personal property of the whole town, 6 50 ; making out the valuation of R. & P.	

estate, 5 00 ; making highway taxes, 2 50 ; writing 13 surveyors lists, 3 50 ; recordingsaid tax lists, 1 50 ; making town,county and parish taxes, 12 00 ; writing tax lists, 5 20 ; writing 3 lists of voters for Nov. meeting, 1 50; making out lists of expenses and getting them printed, 7 00 ; writing 3 lists of voters for March meeting, 1 50; service as Town Clerk for the year, 6 00 | 53 20 |

To M. Crosby, services as assessor, selectman and overseer of poor for the year	15 00
" do. viewing farms 1 day	1 00
" S. Stearns, service as assessor, selectman and everseer of poor for the year	15 00
" Viewing farms one day	1 00
" Going to Harvard and to Chelmsford twice about an overseer of the farm and expenses	4 75
" John Baldwin, service as Treasurer	6 00
" Thomas Sumner, Collector, his commissions	77 83
	$177 03

INCIDENTAL EXPENSES.

To T. Shed, taking care of town-house and town clock one year	13 00
" Repairing desk in town-house	3 75
" J. & H. Baldwin, paid laying up pound wall	1 38
" Paid for transportation of school books	25
" I. Crooker for shingles for town-h.	16 85
" J. & H. Baldwin, interest of money advanced to pay town farm notes	4 19
" J. P. Norton for printing expenses,	9 00
" Paid half expense of shingling townhouse, and some materials	20 85
" F. Richardson for clock ropes	5 25
" T. Shed repairing windows at townhouse	83
" Services about S. Pox hospital	1 51
" J. & H. Baldwin, furniture, &c. for hospital	37 65
" S. Parker, services preparing hospital, &c.	4 04
" L. Saunders jr. nursing, &c. at hospital	29 88
" Postage of letters for the year,	80
" M. Preston, services about the S. Pox hospital, obtaining allowance of the account for the same of the State, and settling the bills	7 20
" J. R. Mills for S. Poxsign board	33
" Stationary for the year	70
" M. Crosby, horse-hire about a new hearse	1 84
" 1 1-2 days' horse and sleigh about S. Pox hospital	3 00
" S. Stearns, use of horse and chaise about new hearse	1 25
" D. Sherman jr. and Henry Poor for use of house for S. Pox hospital	35 00
" T. Shed building hearse body	40 00
" Cap.J. Richardson making cartridges	2 00
" Writing a contract with D. P. Winning for support of western road	75
" Paid John Brown, nursing and removing small pox patient, &c.	8 00
" Drs. Howe & Brown attending small pox patient,	10 00
" Paid for tax-book	62
" J. Wright for preparing Small Pox hospital	1 50
" J. & H. Baldwin, powder and paper for cartridges,	2 99
	$264 41

CREDIT.

Of Josiah Rogers for old bridge plank	$1 00
Of T. Shed, old bridge stuff	1 40
Of sales of S. pox furniture	4 29
Of State for S. pox expenses	130 16
	$136 75

PAUPER EXPENSES.

Salary of superintendent of Town Farm	$225,00
To Mr. Crosby, paid for hay seed, flax and oats,	8 81
" T. Shed, coffin for John T. Dix	2 50
" J. & H. Baldwin for goods for Town farm from April 8 to July 2, 1833, $1,54; 200 lbs Pork $18,00	19 54

To F. Faulkner & Son for goods for town farm from April 1 to July 30, 1833	36 47
" John Stearns for potatoes for same	10 00
" M. Crosby paid for goods for T. farm	20 01
" F. Richardson, beef del'd Mrs. Allen	56
" 221 lbs salt pork for farm	21 00
" T. Davis, goods for Wm. Allen's family	1 52
" J. B. Richardson, for Blacksmith work for farm	9 40
" Digging grave for wid. Stephen Hill	1 50
" J. S. Bowers, attending as sexton wid. Hill's funeral	1 50
" Z. Howe, one years medical attendance upon town's poor	52 00
" F. Faulkner & Son, goods for town farm from Aug. 6, 1833 to Jan. 27, 1834	43 44
" T. Shed, coffin for Mrs Allen	2 50
" M. Preston writing a contract with Edw. Spaulding	50
" A. Needham, conveying negro to farm	75
" City of Boston for support of Dorcas Punchard	3 88
" Publishing advertisement for overseer of town farm	75
" M. Crosby, transporting goods from Boston for town farm	3 00
" Do. journey to Buckland after Patty Whiting; horse & sleigh, time and expenses	18 64
" Paid town of Buckland for support of Pa'ty Whiting	2 17
" N. Stearns, sawing 1650 ft. lumber	45 38
" G. & J. Fletcher, beef 78c. bbl beef 10,00 ; bbl pork 18,00	28 78
" Capt. J. Richardson for boarding and nursing Mrs. Johnson while sick, occasioned by a fracture of the hip	16 00
Paid house of correction in Boston for support of Hannah Williams, Elizabeth Sergeant and Mary Danforth, former years	111 19
To Luther Haynes for goods furnished Wm. Allen's family	3 50
" Edward Spaulding, paid for goods, pork, labor, grain, &c. as per bill	296 35
" David Parker for leather for farm	2 83
" J. & H. Baldwin, goods for farm 3,65; taxes to Tewksbury 5,74	9 39
Paid instalment to M. M. F. Insur. Co.	1 85
	$1000 71
Deduct paid house of correction in Boston for support of former years	111 19
	$889 52

CREDITS.

Of G. & J. Fletcher for calves	29 10
" T. Shed for S. Bruce's Board 9 days	3 00
" N. Stearns for white pine timber	57 80
Cash of state for support of state paupers	5 70
Rent due for wid. Batcheller's land	10 00
Of Edward Spaulding, wood sold 82,67; Boards sold, 140,77; for boarding, 58,25; Straw sold, 15,25; pigs, 6,00; Grain sold, 3,40; meat sold, 7,56; for labor,8,83; use of drag, ,50; making cider, 3,18; use of wagon, 1,50; hay sold, 7,35; butter do. 33c.; vinegar do. ,88; fowls sold, ,50; vegetables sold, 47,39; lumber, 11,36; allowance for sickness in his family and absent time, 21,00; by building 57 rods of wall for which we receive pay of Rail-road Corp'n, 99,75; by work and timber for corner bridge, 6,00	511 01
	$616 61

Amount of Dr.	$889 52
Amount of Cr.	616 61
Amount of Pauper expenses for the year,	$272 91

P. S. To be more accurate in ascertaining our pauper expenses for the year, it will be necessary to add to the above amount, a year's interest upon the cost of our Poor Farm, which would be about $204,00.

Submitted by

MARSHALL PRESTON, } SELECTMEN
SEWALL STEARNS, } OF
DANIEL WILSON. } BILLERICA.

September, 1834.

THE 1833–1834 TOWN EXPENSE REPORT. This 1834 broadside offers a detailed snapshot of town finances. Among the notable expenses were payments for ringing the meetinghouse bell, care for those with smallpox, and obligations to maintain the town's poor farm. (Courtesy of Margaret Ingraham.)

IMAGES
of America

BILLERICA

Billerica Historical Society

ARCADIA

First published 2003
Reprinted 2003, 2004

Published by Arcadia Publishing,
an imprint of Tempus Publishing Inc.
Portsmouth NH, Charleston SC, Chicago,
San Francisco

Printed in Great Britain

Library of Congress Catalog Card Number: 2003102423

For all general information, contact Arcadia Publishing:
Telephone 843-853-2070
Fax 843-853-0044
E-mail sales@arcadiapublishing.com
For customer service and orders:
Toll-free 1-888-313-2665

Visit us on the Internet at www.arcadiapublishing.com

Dedicated with gratitude to Gordon C. Brainerd (1918–2001). For 60 years, he worked for the greater good of his adopted community, Billerica. It is a better place because of him.

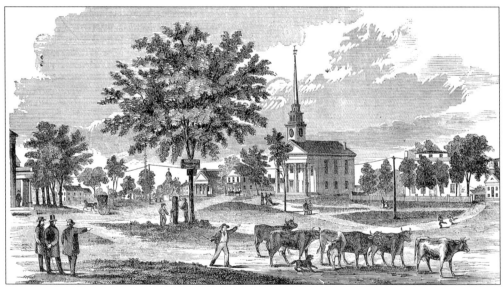

BILLERICA CENTER IN 1858. In this engraving, the Fletcher Hotel is at the immediate left. In the far distance is the Parker-Richardson-Dickinson house. Farther to the right is the steeple of the Baptist church, the Ruggles house, the town hall, store and post office, Unitarian church, Bowers home, and the Universalist church on River Street. In the center is the town water pump. (Courtesy of the Billerica Historical Society.)

CONTENTS

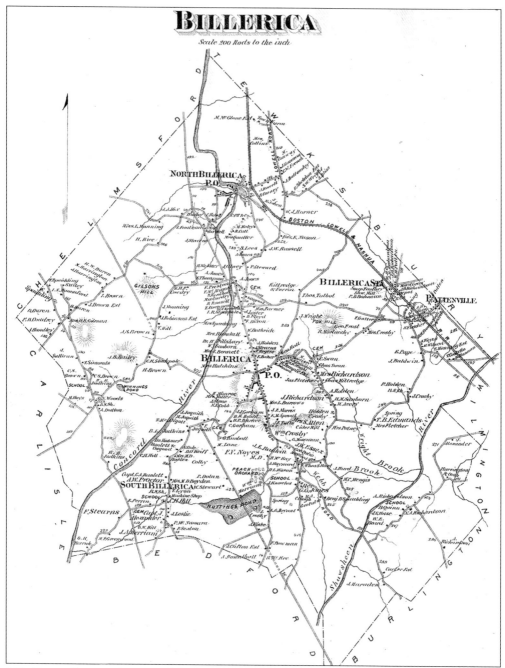

J.B. Beers County Atlas of Middlesex County. Published in New York in 1875, this map details the homes, businesses, and travel routes through Billerica. (Courtesy of David D'Apice.)

INTRODUCTION

Billerica's first written history was recounted in John Farmer's *Historic Memoir of Billerica* (1816), but by far the most vital part of the town's legacy comes from Rev. Henry Hazen's *History of Billerica* (1882), which was the first complete history of the town and was appended with genealogical information.

Billerica, named for the town of Billericay in Essex County, England, was the Shawshin wilderness in 1636, when first mentioned as a potential site for a new plantation. On November 2, 1637, the General Court granted Lt. Gov. Thomas Dudley 1,000 acres and Gov. John Winthrop 1,200 acres. Two great rocks, called the Two Brothers, were to part their lands. These two rocks still lie on the east bank of the Concord River in Bedford, a short distance south of the Billerica line.

On June 2, 1641, Shawshin was granted to Cambridge, provided that a village of 10 families be established there within a span of three years. It was, however, a time of hardship and financial difficulty, and Cambridge was ill prepared to grapple with the challenges of a new settlement so far in the wilderness. The eventual sale of the Dudley Farm in 1652 resulted in the settlement there of several families, chiefly from Woburn.

By 1658, there were some 25 families, and Samuel Whiting became the first minister. Their first meetinghouse was 30 by 24 feet, with a thatched roof, plain seats, and spartan furnishings. Roads were laid out to Woburn, Concord, Chelmsford, and Andover, and bridges were built. Industry began to grow and prosper in the form of sawmills and gristmills. Billerica's two rivers and many brooks powered a number of these early endeavors. With a local economy based on lumber, cattle, and field crops, the village grew. King Philip's War and the French and Indian War resulted in the creation of 10 garrison houses. Between 1692 and 1695, approximately 20 people were killed by Native American attacks. During the Salem witch trials, Martha Carrier, who had moved from Billerica to Andover, was tried and executed after testimony from several of her Billerica neighbors.

When Thomas Ditson was tarred and feathered to the words of "Yankee Doodle" in 1775, Billerica took a heightened interest in the American Revolution. Nearly 400 townspeople took up arms against the British under the spiritual direction of Rev. Henry Cumings. His home has since become the headquarters of the Billerica Historical Society, the gift of Clara E. Sexton upon her death in 1936.

As the town acquired more land, it became one of the largest in the area, with boundaries that included everything from Woburn and Cambridge between the Shawsheen, Merrimack, and Concord Rivers, with a substantial amount of land east of the Shawsheen and west of the Concord. Houses stood on sprawling farms, and each represented a family group, much like the feudal estates of Europe. As the region became more populated, parts of Billerica were set off. These lands would help to create other towns, such as Bedford in 1729, Tewksbury in 1734, Wilmington in 1737, and Carlisle in 1780.

The district school system that had evolved was expanded in the 1790s by Ebeneezer Pemberton, who established a private school in Billerica. Successful for many years, it was joined by Nathaniel Peabody's school in 1804 and was replaced by the Billerica Academy in 1820. By the will of prominent local Dr. Zadok Howe, the Howe School was dedicated in 1852 and became one of the last small private schools, before being replaced with a public high-school system.

What were once footpaths through the woods became roads to support virtually every facet of transportation. The Middlesex Canal, dug by hand and completed on the last day of 1803, brought trade and commerce, connecting Boston and New Hampshire. In 1835, the Boston and Lowell Railroad was opened for traffic. By 1878, a narrow-gauge railroad ran between Billerica and Bedford. The highways and roads were dotted with taverns along Middlesex Turnpike (completed in 1811) and Boston Road.

One of the first social libraries in Billerica began in 1772, and a second was open as early as 1807. By 1880, Eleanor Bennett had given the Bennett Public Library. The building still stands today on the common.

The Industrial Revolution saw the rise of manufacturing in North Billerica, with a great flourish of commerce built around the Faulkner and Talbot Mills. As early as 1811, Francis Faulkner had been making flannels, and the Talbot Dyewood and Chemical Works (1839) and Woolen Mills (1857) were some of the most successful in the state. Thomas Talbot grew famous and wealthy, and in 1878 he became governor of Massachusetts. The Jaquith brothers began a large-scale glue factory near the Concord River at the end of the Civil War. The Hill Machine Shop was established c. 1830, with the exclusive right to manufacture a revolutionary leather-splitting machine previously patented by Samuel Parker of Billerica.

When the Civil War broke out, Billerica contributed its share of manpower, and, deeply stirred by the slavery issue, great numbers joined the battle. They are remembered by the Soldiers' Monument, erected in 1873 on the common. The causes of liberty and country have called Billerica natives throughout the years, from World War I and World War II to Korea, Vietnam, and Desert Storm.

Because of its two rivers, Billerica has always been the home of summer recreation, and many of the summer cottages along the lakes and waterways are still visible today. The development of Pinehurst Park, acres of wooded amusements, complete with dance halls and canoe rentals, brought many from urban areas to enjoy the natural resources. With those interests came the luncheonettes, the diners, and the neighborhood grocery stores. During the Great Depression, numerous summer residents lost their homes in the cities and moved to Billerica permanently.

The Billerica of today is quite different from anything in the history books. It is a large community with a blend of history and high technology, farming and factories. It is the goal of the Billerica Historical Society to preserve our past with this pictorial reference of images from days gone by. By remembering our heritage, we help shape the future, and therein lies the value of many of the photographs in this book—times when the pace of life was slower and beauty was everywhere.

Without the help of the Arcadia Committee, this work would have remained a dream. With a number of scattered and isolated collections spanning centuries, a comprehensive glimpse of the past has been elusive. Special thanks are due to the Billerica Museum for the use of its glass negatives, a world-class, 1,100-plate collection capturing turn-of-the-century Billerica. The tireless dedication of the members of the Arcadia Committee cannot be overlooked—and this book is just the tip of Billerica's historical iceberg. With gratitude, we recognize the efforts of chairman David D'Apice and members Kathy Smutek, Jan Wetzel, Alec Ingraham, Margaret Ingraham, Tom Paskiewicz, and Carol O'Riorden. We gratefully acknowledge the historians of our past, John Farmer, Henry Hazen, Charles Stearns, and A. Warren Stearns, and thank the countless people who scoured their attics and uncovered the fantastic collection you see published here—truly the first of its kind.

One

LANDMARKS

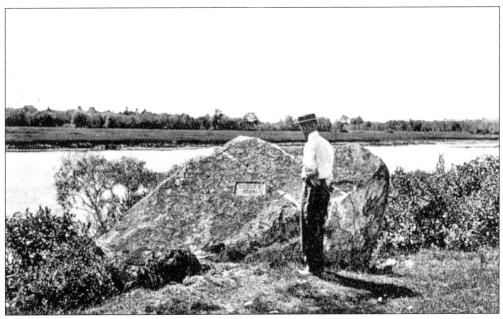

THE TWO BROTHERS. In 1637, the General Court granted Lt. Gov. Thomas Dudley 1,000 acres on the eastern bank of the Concord River. At the same time, it granted some 1,200 acres to Gov. John Winthrop. To mark the parcels of land, two large boulders were selected and referred to as the Two Brothers. One is inscribed with the Winthrop name, the other Dudley, and each bears the date "1638." They remain to this day along the Concord River just over the Bedford town line as one of the earliest reminders of Billerica's past. (Courtesy of David D'Apice.)

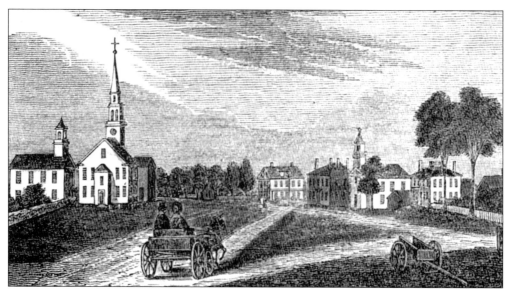

THE BARBER WOODCUT OF 1838. This view from the southern end of Billerica common clearly shows the Unitarian church (with its distinctive steeple) before it was rotated 90 degrees clockwise to face the common. Behind it to the left is the Billerica Academy building. At the corner of Andover Road stands the home of Dr. Thaddeus Brown. Along the right side of the common are the tavern (with a sign in front of it), the town hall and barn (which burned c. 1876), and the Jonathan Bowers home (built c. 1796). On the extreme right is the Orthodox Congregational Church on Andover Road. The cart in the right foreground belonged to the Dickinson family. (Courtesy of David D'Apice.)

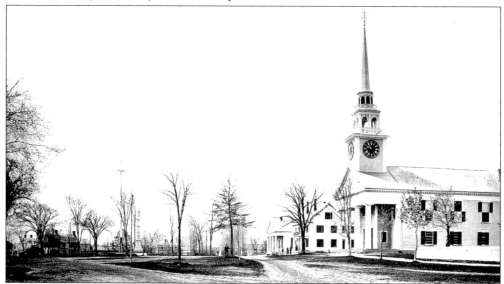

A NORTHERN VIEW OF THE COMMON. This photograph, taken c. 1880, shows how Main Street (today's Route 3A) appeared at the junction of Concord Road. On the right is the Unitarian church. Next to it are the Dolan Cash Grocery Store (today's Masonic Hall), and the old town hall. The Soldiers' Monument (dedicated on October 8, 1873) and flagpole grace the common, and in the distance on the left is the Parker-Richardson-Dickinson homestead. (Courtesy of the Billerica Historical Society.)

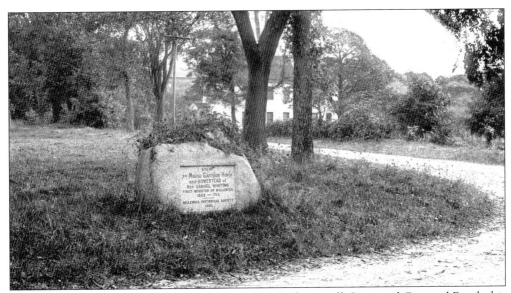

THE MAIN GARRISON MARKER. At the junction of Charnstaffe Lane and Concord Road, this stone tablet marks the site of "ye Maine Garrison House and Homestead of Rev. Samuel Whiting, First Minister of Billerica, 1663–1713." The Billerica Historical Society placed the tablet here in 1900. (Courtesy of the Billerica Museum.)

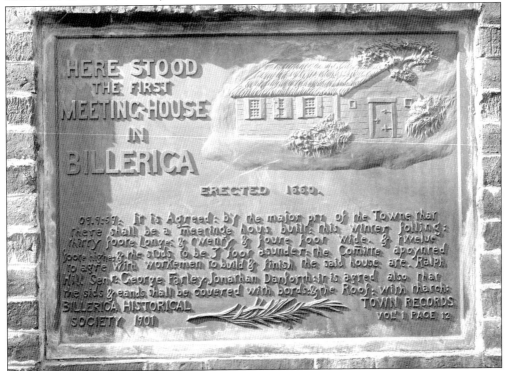

THE FIRST MEETINGHOUSE TABLET. Placed on the common in 1901, this tablet marks the site of Billerica's first meetinghouse, built in 1660. It was a 30- by 24-foot thatched-roof house built by a committee that included Ralph Hill Sr., George Farley, and Jonathan Danforth. (Courtesy of the Billerica Museum.)

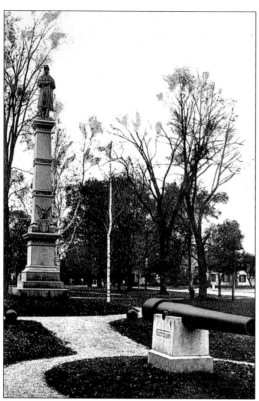

THE CIVIL WAR MONUMENT AND PARROTT RIFLE. This monument, dedicated in 1873, commemorates the soldiers and battles of the Civil War. Originally flanked by cannon balls, the path led to the 4.2-inch-bore Parrott rifle in the foreground. The gun was cast at the West Point Foundry in Cold Spring, New York, in 1865. Although presumably not used in a Civil War battle, it was brought to Billerica and placed on the common in 1907. (Courtesy of Tom Paskiewicz.)

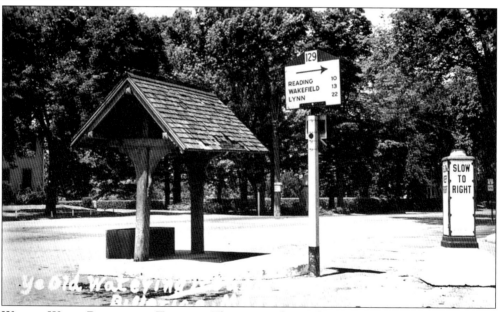

WATER WELL, PUMP, AND TROUGH. This image shows the site of the town pump at the junction of Andover and Boston Roads. The pump was provided with a granite trough in 1881 by the Billerica Village Improvement Association. It was not until about a century later that the entire overhang and components were moved to River Street so that traffic could more efficiently move through the center of town. (Courtesy of Tom Paskiewicz.)

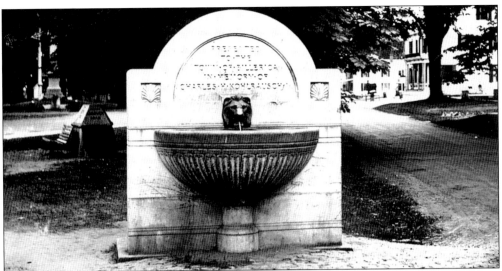

The Charles H. Kohlrausch Memorial Fountain. Having served as town moderator, chairman of the selectmen, water commissioner, state representative, and superintendent of the Chemical Works at North Billerica at different times, Charles H. Kohlrausch was involved in a great deal of Billerica's progress. In 1912, his family donated this fountain to the town in his memory. The fountain stood at the north end of the common until it was moved to River Street in 1930. (Courtesy of David D'Apice.)

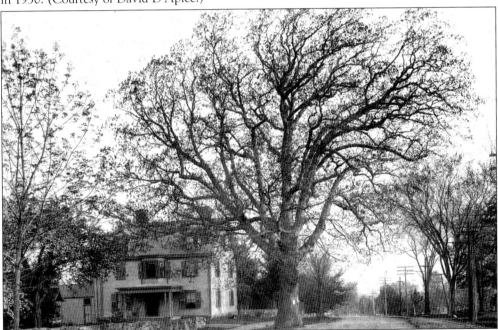

The Washington Oak. One of the most notable landmarks in town, this tree stood when George Washington passed through Billerica on November 5, 1789, during his tour of New England. Washington traveled from Billerica to Lexington with Samuel Phillips of Andover. A commemorative plaque was placed by the Billerica Historical Society in 1896, and the tree stood until Hurricane Gloria damaged it in 1985. Seen on the left, the home of Samuel Foster, on Boston Road, still stands today. This photograph was taken in 1895. (Courtesy of Arthur Giles.)

13

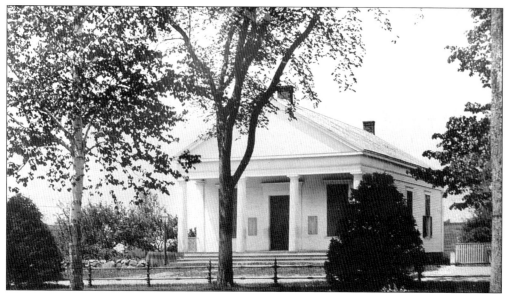

THE OLD TOWN HALL. Not the first town hall, this Greek Revival building stood where the Billerica Public Library stands today. It was built in 1844 and burned in 1893. (Courtesy of the Billerica Historical Society.)

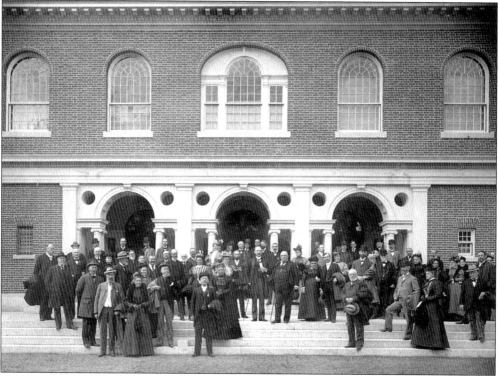

THE DEDICATION OF THE TOWN HALL. Currently the public library, Billerica Town Hall is pictured here at its dedication on November 8, 1895. It served as the town hall until c. 1989, when it was abandoned and subsequently restored to house the library. (Courtesy of the Billerica Historical Society.)

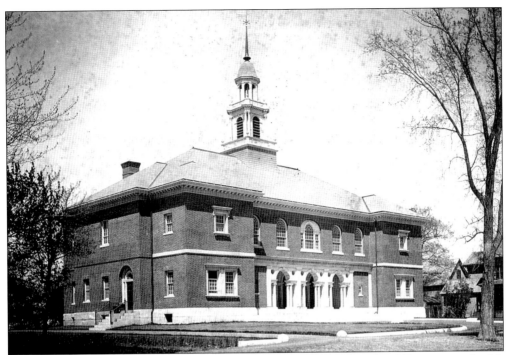

THE BILLERICA TOWN HALL. With Palladian windows and Christopher Wren–inspired gold-leaf cupola, the town hall is pictured as it appeared when completed in 1895. H. Langford Warren and Lewis H. Bacon were noted for designing the building. (Courtesy of the Billerica Historical Society.)

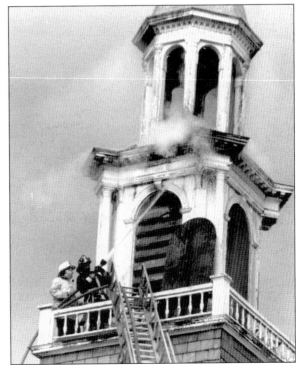

LIGHTNING STRIKES THE TOWN HALL CUPOLA. After a lightning strike on July 7, 1993, the town hall cupola was condemned and removed for complete reconstruction. Firefighters quickly subdued the blaze, which did little damage to the building itself. (Courtesy of the Billerica Historical Society.)

THE SOLOMON POLLARD TAVERN. Originally built as a garrison house on Boston Road in 1682 by Jonathan Danforth Jr., this tamarack-floored, center-chimney homestead featured masonry-lined walls for defensive purposes. The house became a tavern *c.* 1710 under the ownership of Ephraim Kidder. Solomon Pollard acquired the tavern in 1768, and it served as a gathering place for the local militia during the Revolutionary War. This photograph was taken in 1925. The tavern burned in 1977. (Courtesy of the Billerica Historical Society.)

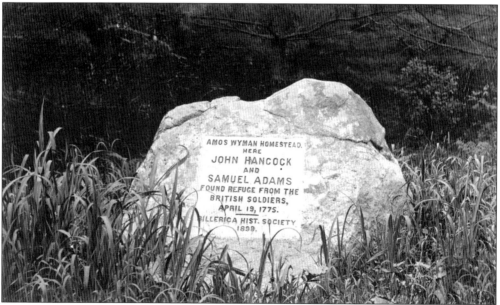

THE AMOS WYMAN HOMESTEAD MARKER. This huge stone marks the location of the Amos Wyman homestead, in the woods just off Middlesex Turnpike where Billerica meets Bedford. The rock was inscribed by the Billerica Historical Society in 1898 and commemorates the fateful day of April 19, 1775, when John Hancock and Samuel Adams took refuge from British pursuits at the Wyman home. For their hospitality, Hancock later rewarded the Wyman family with the gift of a cow. (Courtesy of the Billerica Historical Society.)

THE ASA POLLARD MARKER. This stone marker, which is still in place today at the corner of Call and Pollard Streets, graces the birthplace of Asa Pollard. The home was built by Thomas Pollard in 1692. In the foreground are the trolley tracks that ran from the center to North Billerica. (Courtesy of the Billerica Historical Society.)

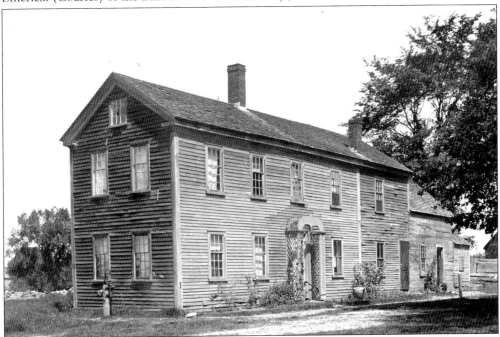

THE ASA POLLARD BIRTHPLACE. Asa Pollard was born in this house, and he is known as the first American killed at the Battle of Bunker Hill. The home burned in November 1908 during the ownership of J. Henry Call. The barn and animals were saved, but only one wall of the house remained after the blaze. (Courtesy of the Billerica Museum.)

BENNETT HALL. Once the home of Joshua and Eleanor Bennett, this stately home stood on Boston Road at the intersection with Good Street. Joshua Bennett came to Billerica in 1821. Bennett Hall was set on a substantial tract of land, with guest houses, stables, and windmills. At the time, it was one of the most opulent homes in Billerica. The hall underwent a number of renovations, the most notable in 1890, two years before Joshua Bennett Holden Jr. inherited it. (Courtesy of the Billerica Historical Society.)

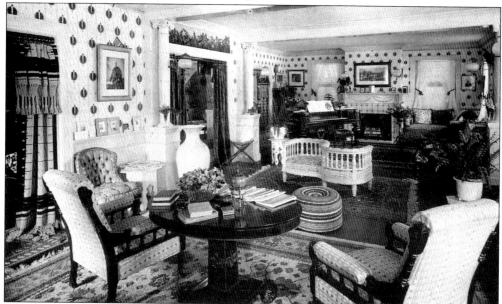

THE BENNETT HALL PARLOR. Lavishly appointed with treasures from around the world, this quintessential Victorian parlor was a reception room for the Bennetts and their guests. When it was no longer a private home, Bennett Hall became the Johnny Cake Inn, a country bed-and-breakfast run by Mary H. Hubbard. With dancing, billiards, canoeing, and chicken, steak, and chop dinners served for $2, the inn featured luxurious accommodations and produce from the estate's farm. The property was razed c. 1956. (Courtesy of the Billerica Historical Society.)

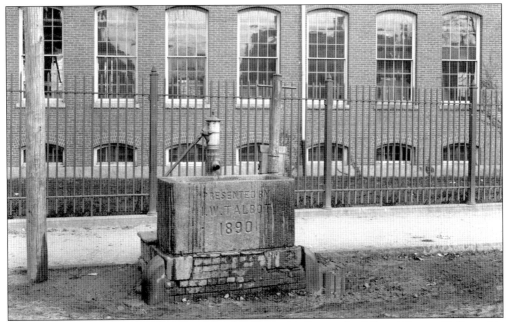

THE TALBOT WATER TROUGH. A gift of Isabella W. Talbot, wife of Gov. Thomas Talbot, this granite trough was located at the junction of Elm and Wilson Streets in North Billerica and has the year 1890 engraved on it. This photograph was taken *c.* 1898. (Courtesy of the Billerica Historical Society.)

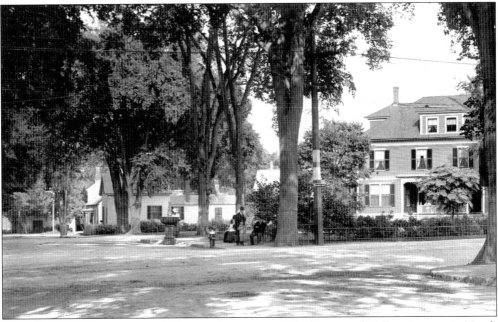

THE ELM STREET FOUNTAIN. Taken at the corner of Elm Street and Talbot Avenue in North Billerica, this view shows the cast-iron fountain that graced the square. The fountain was the gift of Isabella White Talbot Clark, daughter of Gov. Thomas Talbot. This junction was also the home of the North Billerica bandstand and a cannon captured from German forces in World War I. (Courtesy of the Billerica Museum.)

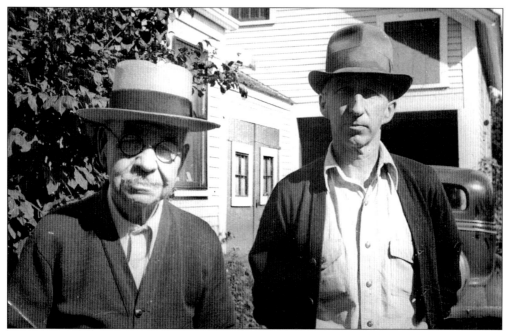

WILLIAM H. SEXTON AND MALCOLM DUTTON. William Sexton and Malcolm Dutton appear outside of the Sexton house on Concord Road. William and Clara Sexton donated their home to the Billerica Historical Society in 1936. Malcolm Dutton was a plumber by trade and the curator of the Sexton house. This photograph was taken by Fred Sexton *c.* 1936. (Courtesy of Richard Nardini.)

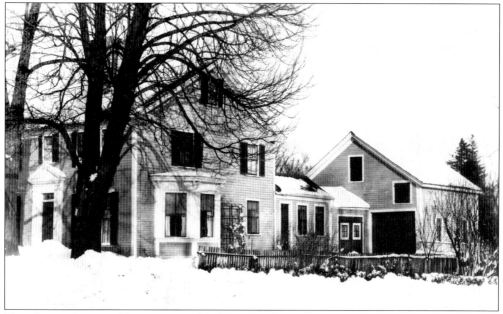

THE CLARA SEXTON HOUSE. Remodeled in 1763 for Rev. Henry Cumings, fourth minister of the Unitarian church, this center-chimney home still stands on Concord Road. It was left to the Billerica Historical Society by Clara E. Sexton in 1936. Portions of the house may date back as early as 1723. (Courtesy of the Billerica Historical Society.)

Two
TRANSPORTATION

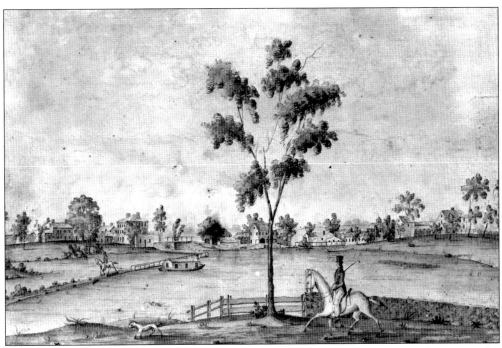

A MIDDLESEX CANAL WATERCOLOR. Painted by Jabez Ward Barton *c.* 1825, this watercolor features the floating towpath on the Concord River millpond at North Billerica. The buildings pictured on the northwestern side of the millpond include, from left to right, Mears Tavern Stand, Capt. Joel Dix's house, the lock tender's house, John Mixer and Daniel Wilson's house, a three-story boardinghouse, a blacksmith shop, the canal entrance, a sawmill, a gristmill, a bridge, an ironworks and foundry, the Faulkner Mill, and Francis Faulkner's house. The boy towing the canal boat is Joseph Ruggles. (Courtesy of the Billerica Historical Society.)

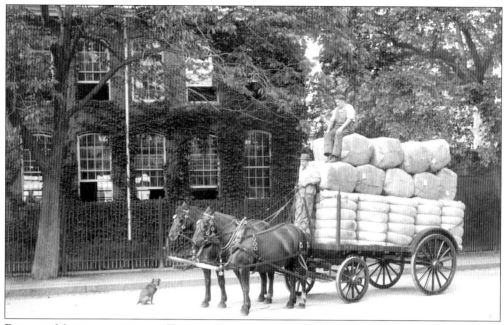

PATRICK MONOHAN AND THE TALBOT RIG. Taken *c.* 1907 with the Talbot Mills Repair Shop in the background, this photograph shows a wagon loaded with wool for the Talbot Mills on Elm Street. (Courtesy of the Billerica Historical Society.)

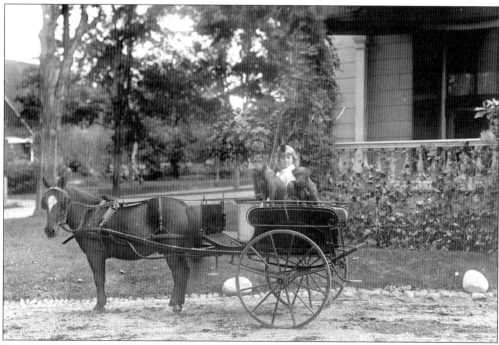

GRACE HELEN TALBOT AND HER PONY CART. Grace Helen is shown spending a morning with her two dogs in front of their family home on Mount Pleasant Street in North Billerica. In the distance to the left, the Joseph Talbot home, built *c.* 1893, is visible. It is still extant. This photograph was taken *c.* 1905. (Courtesy of the Billerica Museum.)

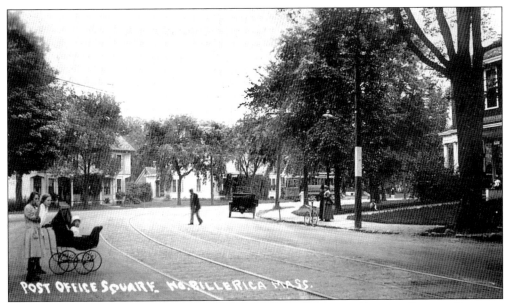

POST OFFICE SQUARE, AT THE JUNCTION OF TALBOT AVENUE AND ELM AND LOWELL STREETS. Taken *c.* 1920 in North Billerica, this photograph shows the transportation options of the day. At the left are two young women with a baby in a pram. In the center is a Model T Ford, in the distance is the trolley, and on the sidewalk is a bicycle. Post Office Square got its name from the building on the far right, which housed the North Billerica post office and the Talbot Mills Library on the second floor. (Courtesy of David D'Apice.)

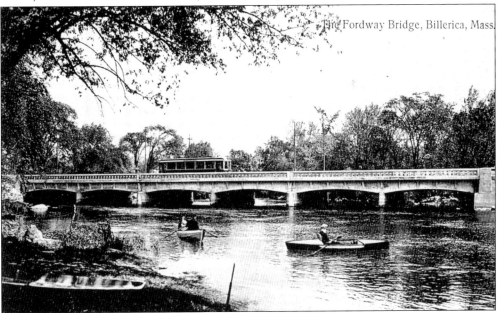

THE FORDWAY BRIDGE. On Pollard Street in North Billerica, the Fordway Bridge was located near the site of the first bridge crossing the Concord River. It was built possibly as early as 1657. This bridge was built in 1912, replacing an earlier iron bridge from 1893, which had proved impractical for trolley traffic. This photograph was taken when the bridge was fairly new and shows the trolley crossing the river. (Courtesy of Tom Paskiewicz.)

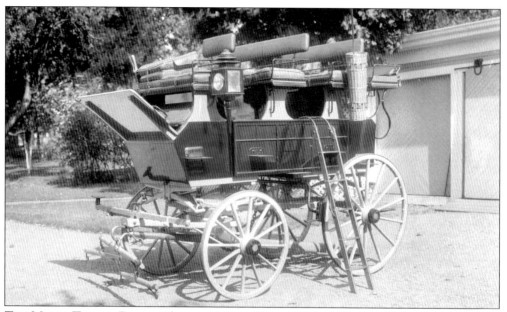

THE MAJOR TALBOT BREAK. The son of Gov. Thomas Talbot, Thomas Talbot Jr. entered the Spanish-American War as a second lieutenant and, after returning from the Philippines, had obtained the rank of captain. He traveled using this break, housed at the Talbot estate in North Billerica. Used mostly for picnics and outings, the break was so named because it was designed to break in or train young and inexperienced horses. The vehicle's high seat afforded the driver visibility, safety, and control over the untrained team. This photograph was taken in October 1910. (Courtesy of the Billerica Museum.)

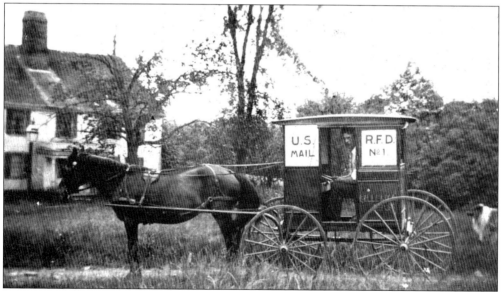

RURAL FREE DELIVERY NO. 1 MAIL BUGGY. The rural free delivery system began in the late 1890s, and Route No. 1 was established to provide mail delivery to Billerica Center and the surrounding area. In 1906, Route No. 2 began, with service to North Billerica. The driver is John Franklin Fuller, shown with Dolly the horse and Beau the collie. They appear in front of the Bear Hill Farm, on Boston Road, *c.* 1900. (Courtesy of Charles Kennelly.)

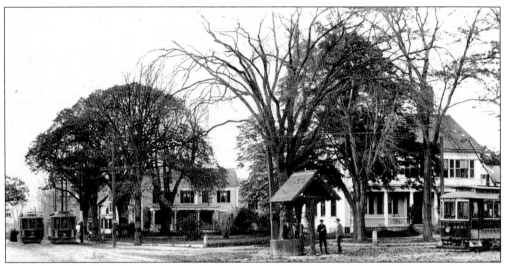

BILLERICA CENTER. The center is seen here at the corner of Andover and Boston Roads. On the left are two trolleys of the Lexington and Boston Street Railway in front of the Unitarian parsonage, built as the home of Marshall Preston *c.* 1827. In the foreground, the water trough and pump appear, and in the background is the Thaddeus Brown–Luther Faulkner homestead, with a Bay State Street Railway trolley in front. Trolley service that converged in Billerica center connected to Wilmington, Bedford, and Woburn. At one time, there were three trolley companies operating different routes through the center. This photograph was taken *c.* 1915. (Courtesy of Tom Paskiewicz.)

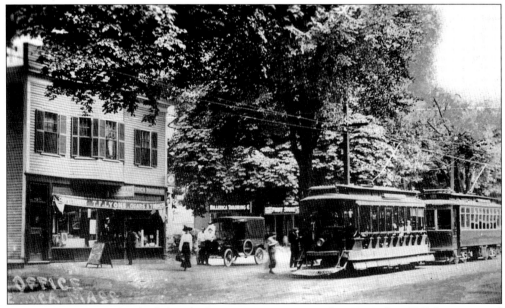

BILLERICA CENTER. On the left is the Lyons store, constructed in 1914 when T.F. Lyons moved from a smaller store that stood where Billerica Access Television stands today. Expanded, the building still stands on Boston Road. To the near right is the Billerica Tailoring Company, which was located in the Faulkner house, and on the farther right is the Lexington and Boston Street Railway open car, in front of the Bay State Street Railway closed trolley. (Courtesy of Kevin Farrell.)

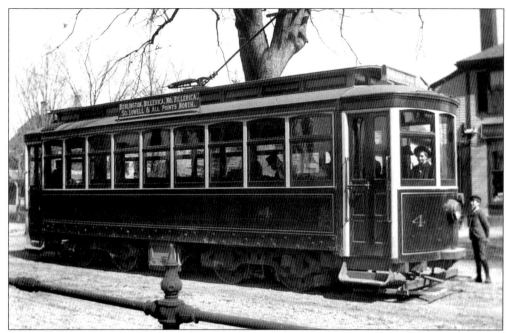

A BILLERICA CENTER TROLLEY. The Lowell and Boston Street Railway's car No. 4 is shown here at Billerica center c. 1902. This photograph was taken at about the time the line opened, in front of what is today the Center Cafe. In the foreground is the ornate cast-iron fence that once outlined the town common. (Courtesy of Kevin Farrell.)

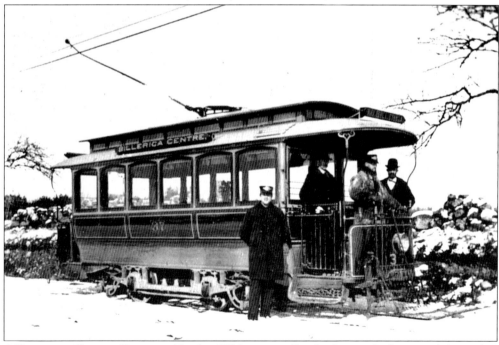

A BILLERICA CENTER TROLLEY. Until c. 1904, most trolleys had open platforms, and this earlier style likely precedes that date. This is car No. 37, which ran from Wilmington to the center and then to North Billerica. The date of the photograph is c. 1902. (Courtesy of David D'Apice.)

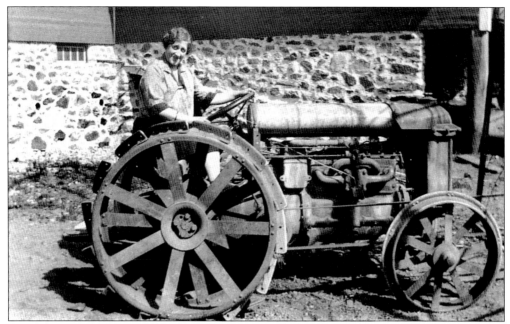

ANNIE MARTIN. Taken in the 1930s, this photograph shows Annie Martin driving the Fordson tractor on her family farm, once located at the corner of Lexington Road and the Middlesex Turnpike. Built as the Bowman Tavern *c.* 1804, it was a functioning agricultural farm and restaurant known as Martin's Old Tavern Farm. (Courtesy of Eleanor Martin.)

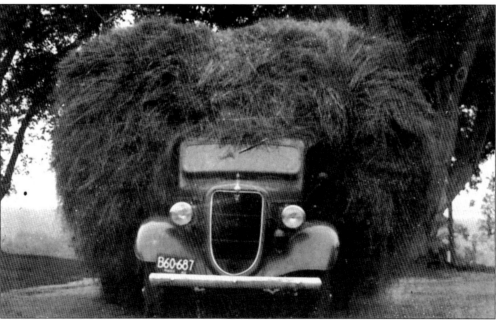

THE KENNELLY FARM HAY WAGON. Taken in 1943, this photograph shows Charles Kennelly's 1935 Ford making its way toward the Kennelly Farm with a load of hay just harvested from the Sebastian Farm in Burlington. The hay was used to feed livestock at the farm. What seems whimsical was actually the most efficient way of stacking hay on a vehicle and could effectively triple the load. (Courtesy of Charles Kennelly.)

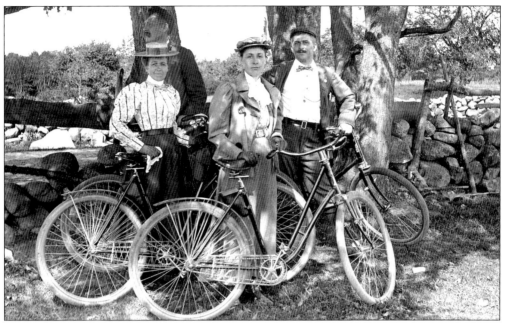

THE KOHLRAUSCHS ON BICYCLES. Matthew and Frances Kohlrausch (left) join an unidentified couple for a bike ride at the turn of the century. With few motorcars in the town, bicycles were still one of the most efficient ways to travel and enjoy the local landscape. (Courtesy of the Billerica Historical Society.)

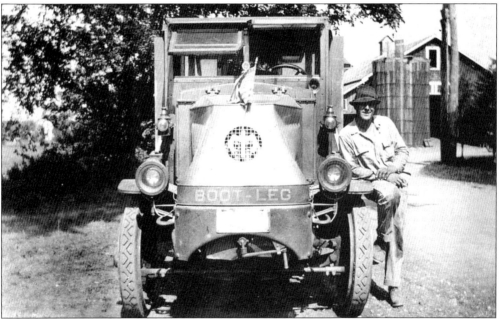

JOSEPH MARTIN SR. WITH A MACK TRUCK. This 1920s photograph shows Joseph Martin standing alongside his Mack truck, complete with acetylene headlights and kerosene side lamps. This truck was used to bring straps of molasses from Boston to feed farm animals and to haul produce on the Martin Farm, at the junction of Lexington Road and the Middlesex Turnpike. (Courtesy of Eleanor Martin.)

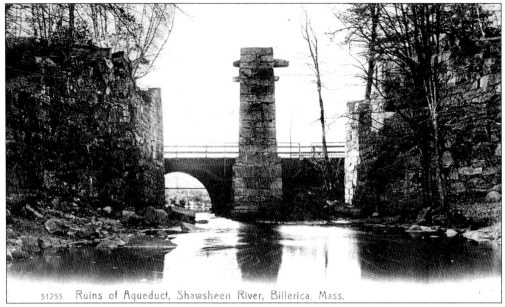

51233 Ruins of Aqueduct, Shawsheen River, Billerica, Mass.

THE SHAWSHEEN RIVER AQUEDUCT. Once a marvel of the Middlesex Canal, the Shawsheen Aqueduct was constructed prior to 1803 and was rebuilt to its current scale between 1841 and 1842. It consisted of a large wooden trough that crossed the center stone, through which water and canal boats could travel to get across the Shawsheen River. In 1967, the Middlesex Canal and the Shawsheen Aqueduct were recognized as a National Civil Engineering Landmark by the American Society of Civil Engineers. (Courtesy of Kathy Smutek.)

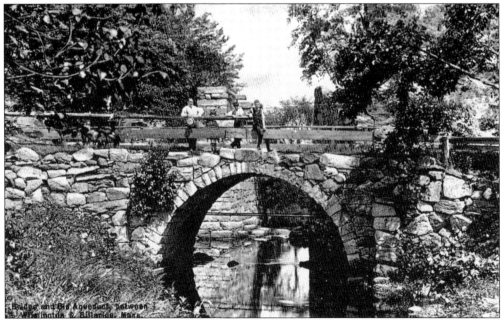

THE SHAWSHEEN RIVER BRIDGE. Seen from the other side, the aqueduct appears in the background behind the Shawsheen River Bridge on Route 129 at the Wilmington town line. The Middlesex Canal and the Shawsheen Aqueduct were placed on the National Register of Historic Places in 1972. This photograph was taken in 1913. (Courtesy of Tom Paskiewicz.)

A NORTH BILLERICA RAIL CREW. This maintenance crew appears at the North Billerica Boston and Maine depot before the turn of the century. In the background is the ticket master, who was likely a telegrapher as well. Their identities are a mystery, but this remains one of the earliest photographs known of railroad employees at the station. (Courtesy of David D'Apice.)

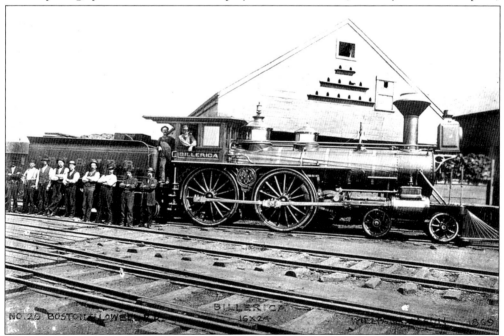

A BOSTON AND LOWELL ENGINE. With engines named after towns, this iron horse was known as Billerica engine No. 20. It was built by William Mason in 1869, complete with 16- by 24-inch steam cylinders, and weighed 60,800 pounds. This photograph was taken c. 1875. (Courtesy of David D'Apice.)

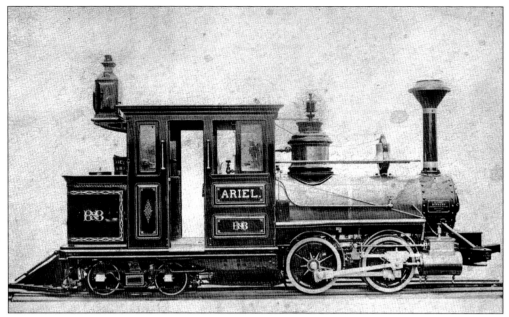

THE *ARIEL.* Begun as the brainchild of George Mansfield in 1878, the Billerica and Bedford Railroad was the first two-foot narrow-gauge railroad in the United States, and its destiny was ill fated. Mansfield also developed the famous Cog Railway. Built by the Hinkley Locomotive Works in Boston, the *Ariel* was one of two engines created for the railroad, which was abandoned within the first year. (Courtesy of Kevin Farrell.)

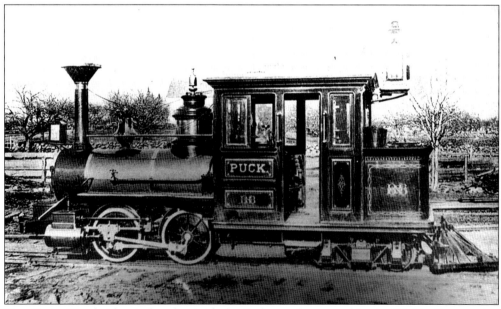

THE *PUCK.* Nearly identical to the *Ariel,* the *Puck* was also created by the Hinkley Locomotive Works. Taken *c.* 1878, this view shows the engine in use before the entire railroad was scrapped and sold to the Sandy River Railroad in Maine. (Courtesy of David D'Apice.)

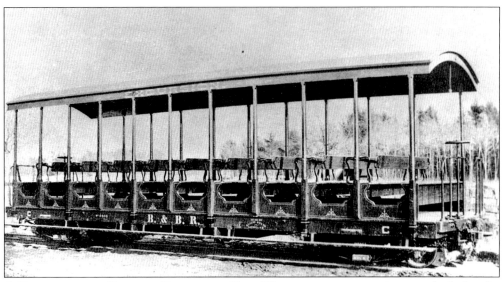

A BILLERICA AND BEDFORD EXCURSION CAR. There were two excursion cars built for the railroad by the Ranlett Manufacturing Company in Laconia, New Hampshire. With a capacity of 55 passengers and weighing in at 5,500 pounds, the cars could be converted into flatcars with the removal of the stake bodies. (Courtesy of Arthur Giles.)

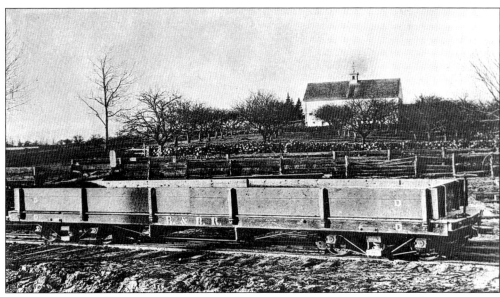

A BILLERICA AND BEDFORD FLATCAR OR COAL CAR. Weighing 4,500 pounds, the coal car was 25 feet long and had been manufactured by Ranlett Manufacturing Company in Laconia, New Hampshire. (Courtesy of Arthur Giles.)

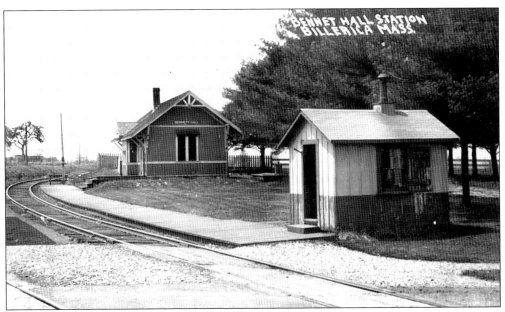

THE BENNETT HALL STATION. Built *c.* 1885, this station stood where the train tracks cross Boston Road just north of Billerica center. It was named for the Bennett estate, which stood farther south. This photograph was taken *c.* 1910 and clearly shows the station and the flagman's shack. When the train approached, the flagman would stop traffic on Boston Road so that the train could pass safely. (Courtesy of David D'Apice.)

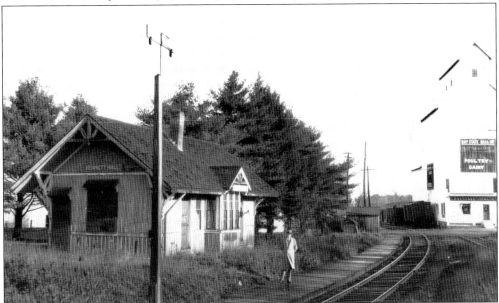

THE BENNETT HALL STATION. Taken in the late 1920s from the southwestern side of Boston Road, this photograph shows Bennett Hall station and the flagman's shack. On the right is the coal and grain silo of Elmer E. Cole, dealer in coals, feeds, and grains, and agent for the Bay State Coal Company. The grain silo pictured here replaced one that burned in 1908. The intense fire spread to nearby dwellings and for a time threatened the center. A spark from a railroad engine was blamed for triggering the blaze. The silo was taken down *c.* 1956. (Courtesy of Kevin Farrell.)

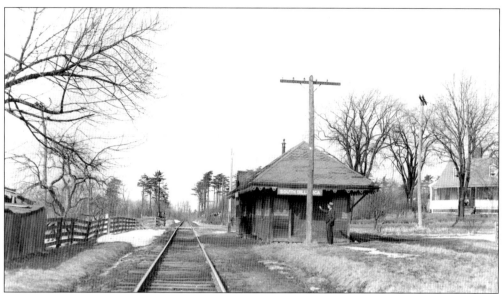

THE SOUTH BILLERICA STATION. Taken in 1934, this photograph shows the South Billerica train station, located on Springs Road. (Courtesy of Kevin Farrell.)

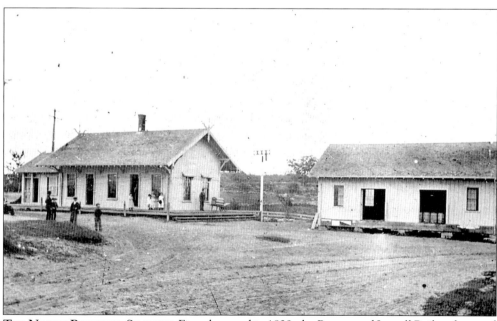

THE NORTH BILLERICA STATION. First chartered in 1829, the Boston and Lowell Railroad opened a line from Boston to Lowell in 1835. In 1867, the Talbot family sold the land to the railroad, and a station was built. This is possibly the earliest image of the depot, complete with its baggage storehouse, photographed c. 1875. The station remains an active commuter railroad station to this day, having been fully restored in 1998. (Courtesy of the Billerica Historical Society.)

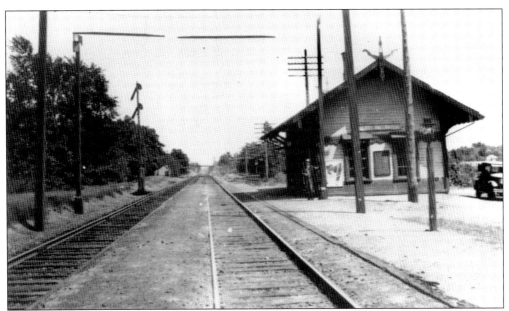

THE EAST BILLERICA STATION. This photograph was taken in the late 1920s and shows the East Billerica train station, just adjacent to Gray Street below the south side of the railroad bridge. The station was located on the west side of the train tracks. (Courtesy of Kevin Farrell.)

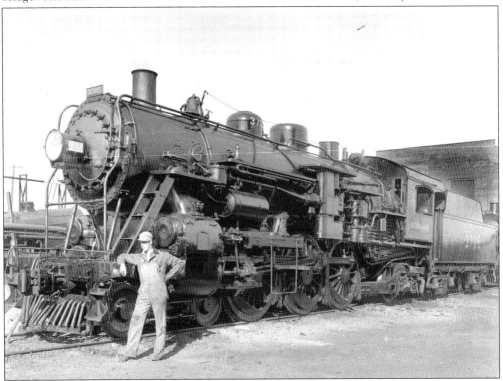

BOSTON AND MAINE LOCOMOTIVE NO. 3705. This Pacific-type locomotive is shown c. 1925 outside the Billerica Car Shops in Iron Horse Park. No. 3705 was manufactured by the American Locomotive Company. (Courtesy of Kevin Farrell.)

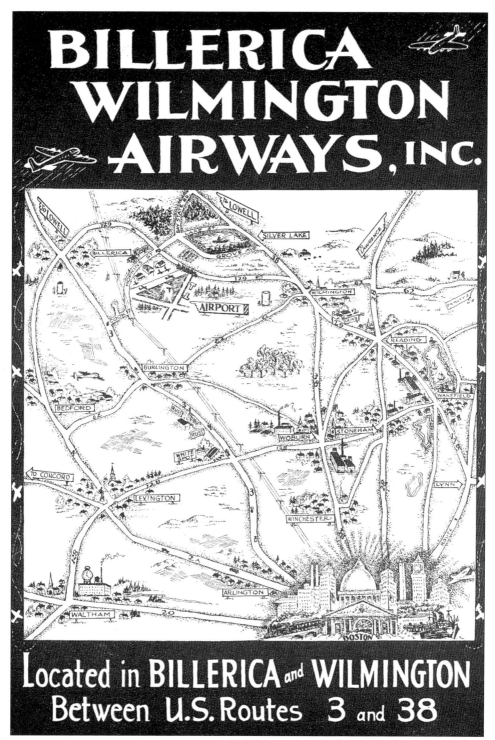

BILLERICA-WILMINGTON AIRPORT. Located off Alexander Road in Pinehurst, the airport was featured in this brochure from the late 1940s. Also listed were a number of war-surplus planes for sale, some for as little as $1,000. (Courtesy of Tom Paskiewicz.)

Three

ORGANIZATIONS

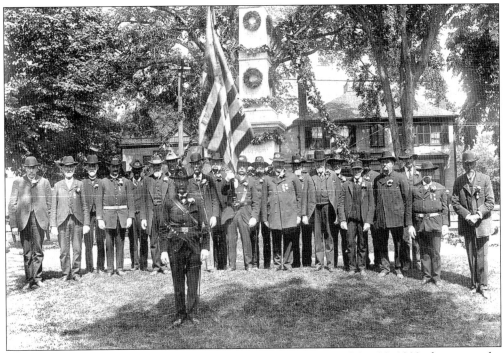

CIVIL WAR VETERANS. When they appeared on the common on May 30, 1903, these were the remaining members of the Grand Army of the Republic. Under the command of Coburn A. Smith are, from left to right, Alden O. Dane, ? Hayes, Dr. Hosmer, Joseph Hill, Timothy Pasho, Voluntine Rollins, Jasper F. Bruce, Ora Bohannon, Nathan Foster, two men who were the color bearers, Prescott Tully, ? Fletcher, unidentified, Franklin Jaquith, Frank Gillespie, four unidentified men, and Marcus M. Cowdrey. They stand at the base of the Civil War monument, located on the common. In the background are T.F. Lyons's post office and Bruce's General Store. (Courtesy of the Billerica Historical Society.)

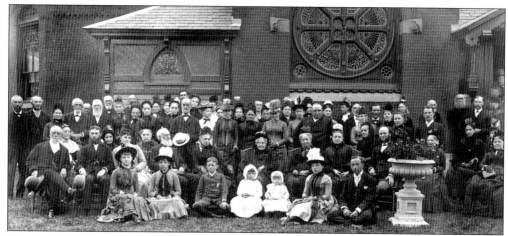

THE BENNETT LIBRARY DEDICATION. The gift of Eleanor Bennett, the library was dedicated in 1880. Designed by noted architect George Tilden, it was the height of Victorian design. Eleanor Bennett is seen here surrounded by well-wishers, including her grandson Joshua Bennett Holden, daughters Ellen Holden and Rebecca Bennett Warren, great-grandson Joshua Bennett Holden Jr., and Luther and Martha Faulkner. (Courtesy of the Billerica Historical Society.)

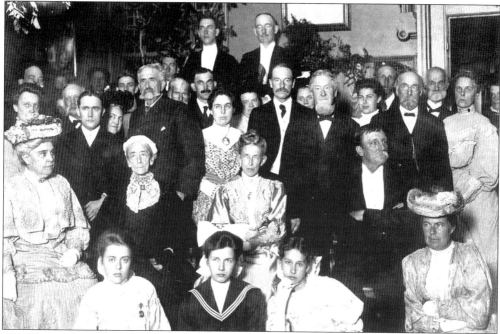

THE BENNETT LIBRARY ANNIVERSARY. The 25th-anniversary celebration of the Bennett Library was well attended by many of the people who had witnessed the dedication years earlier. Eleanor Bennett had passed away. This 1905 view includes Anna Jaquith, Elsie Carr, Wihla Morris, Mrs. Kohlrausch, Mrs. J. Nelson Parker, Martha Faulkner, Martha Dodge, Charles Kohlrausch, Mary Eames, Albert Richardson, Matthew Kohlrausch, Mrs. Edward Dickinson, Edward Dickinson, Mr. Edwin Blodgett, Dr. Flanders, Fannie Flanders, Frank Lyons, Joseph Jaquith, Mrs. Joseph Jaquith, Franklin Jaquith, Herbert King, Lucy King, Carrie Cook, May Blaikie, Dr. Hosmer, Mrs. George Greenwood, George Parker, Edgar Weirs, J. Nelson Parker, George Greenwood. (Courtesy of the Billerica Historical Society.)

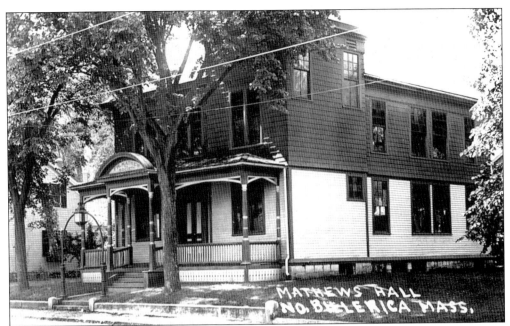

The Total Abstinence Society Hall. Begun in 1838 by Fr. Theobald Mathew, the Total Abstinence Society dedicated this hall on Lowell Street in 1890. The land had been donated by the Talbot Mills. This photograph was taken *c.* 1910, and the building is still in existence. (Courtesy of David D'Apice.)

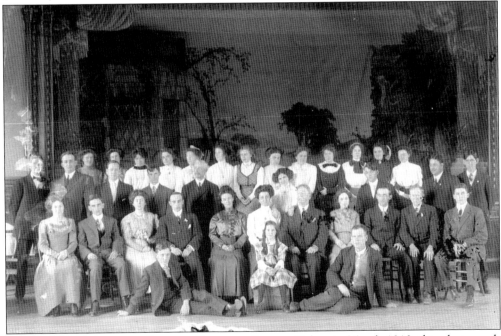

The Total Abstinence Society Theater Group. Taken in March 1910, this photograph shows the Father Mathew Theatre Arts Group on the stage of the Talbot Memorial Hall in North Billerica. The hall was constructed in 1891 and is no longer extant. (Courtesy of the Billerica Museum.)

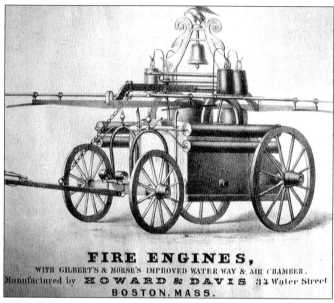

FIRE ENGINES,
WITH GILBERT'S & MORSE'S IMPROVED WATER WAY & AIR CHAMBER.
Manufactured by HOWARD & DAVIS 34 Water Street
BOSTON, MASS.

A HOWARD AND DAVIS ADVERTISEMENT. Howard and Davis was a maker of clocks, scales, and fire apparatus. This printed advertisement appears pasted inside the official town of Billerica scale, once in the town hall and now housed in the Billerica Museum. It shows a nearly perfect depiction of Billerica's first fire engine, the *Hero*. (Courtesy of David D'Apice.)

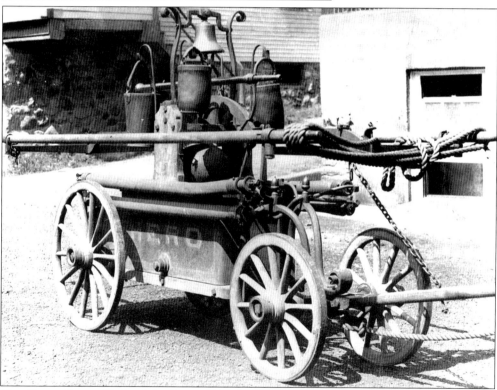

THE *HERO*. Pictured behind the Central Fire Station is the *Hero*, purchased in 1852 from W.C. Hunneman, a dealer in fire equipment. Complete with leather fire buckets to throw water or sand and a hand-pump mechanism to spray water, the *Hero* was the only protection that farmers had from the total devastation that an out-of-control fire could create. The *Hero* cost the town of Billerica some $500. It has been completely restored to its original condition. (Courtesy of Margaret Ingraham.)

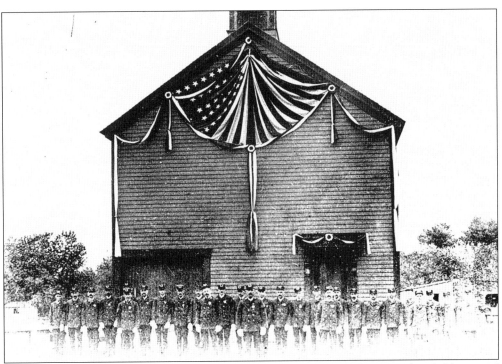

THE ENGINE HOUSE ON WILSON STREET. One of the earliest engine houses and probably created to support the mills, this barn on Wilson Street appears draped in patriotic bunting, surrounded by the fire department as its members appeared in 1890. (Courtesy of Joseph Bradley.)

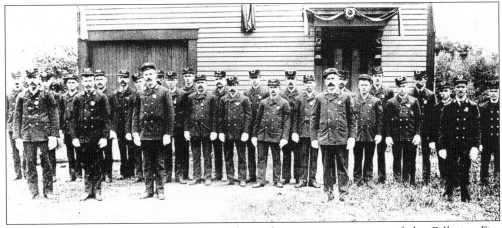

THE FIRE DEPARTMENT. This is one of the earliest surviving images of the Billerica Fire Department, first organized when the town meeting of 1838 authorized a stipend for volunteers. Pictured is the Hero No. 2 Fire Engine Company. This photograph was taken on Wilson Street in 1890. From left to right are the following: (front row) Martin Conway, John Mooney, Tim Mahoney, Jim Corrigan, and Henry Mahoney; (middle row) Bill Taylor, Charles Fairbrother, Daniel Dewire, Jerry Mahoney, Bob Crawford, John Hannon, Elias Hannon, John Conway, Billie Burgone, Dan Callahan, Owen O'Toole, Gus Cowdrey, William Hannon, and Patrick Conway; (back row) unidentified, Tom Callahan, Jerry Mahoney, William Maxwell, Bill Gannon, unidentified, Mike Coughlin, and Will Conway. (Courtesy of Joseph Bradley.)

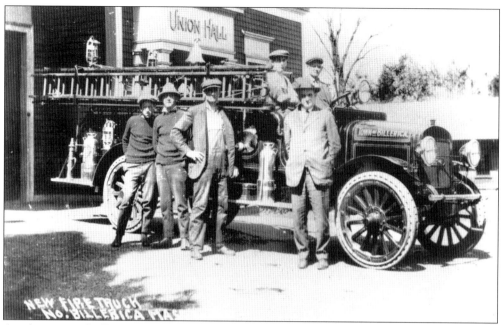

AN AMERICAN-LaFRANCE COMBINATION CHEMICAL AND HOSE WAGON. Taken outside the Union Hall Fire Station in North Billerica, this image shows Combination No. 1, a 1920 Brockaway American-LaFrance fire truck. The truck served North Billerica from 1920 to 1937. (Courtesy of the Billerica Public Library.)

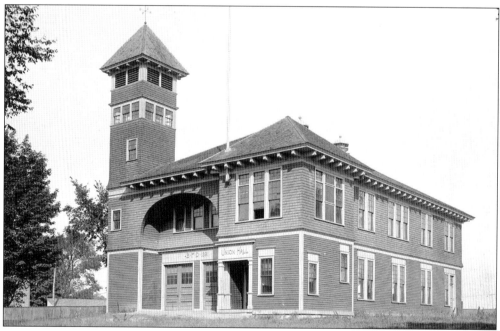

UNION HALL. Originally built *c.* 1871 as a school and used as the North Billerica town hall, Union Hall was rebuilt in 1891 after a substantial fire. It was expanded to include the North Billerica Fire Station, and a tower was added. Photographed *c.* 1903, Union Hall replaced the earlier engine house that was located on Wilson Street. (Courtesy of the Billerica Museum.)

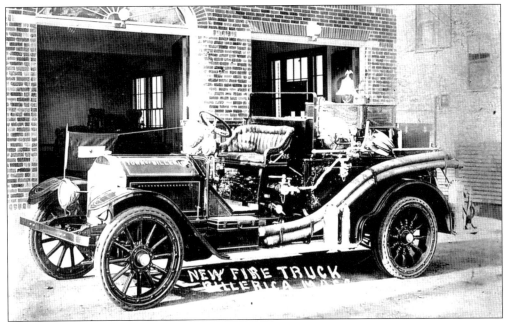

THE FIRE CHIEF'S CAR. Pictured outside the Central Fire Station is the first chief's car, a 1920 Cadillac. The Central Fire Station, located just south of the common on Boston Road, was constructed *c.* 1917. The facade was eventually altered to accommodate larger fire apparatus. Despite the fact that the Central Fire Station was poised to respond with state-of-the-art engines, the North Billerica Fire Station still relied on horses to pull fire equipment even as late as 1918. When no teams could respond to an alarm, men would walk to help fight the blaze. (Courtesy of Tom Paskiewicz.)

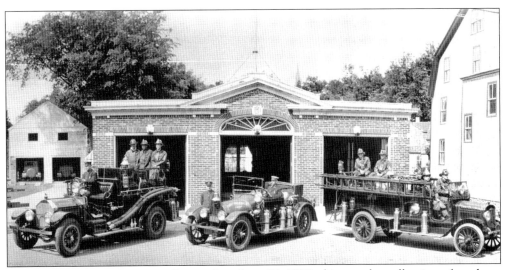

THE CENTRAL FIRE STATION. Pictured on June 17, 1928, this was the collection of trucks at the station. To the right is the Martin block, one of the multifamily tenements that housed center residents. In 1918, plans were under way to move the fire alarm box from the telephone exchange, located in T.F. Lyons's home on Andover Road. Lyons had monitored the alarm at no expense to the town since it had been installed in 1915. (Courtesy of Joseph Bradley.)

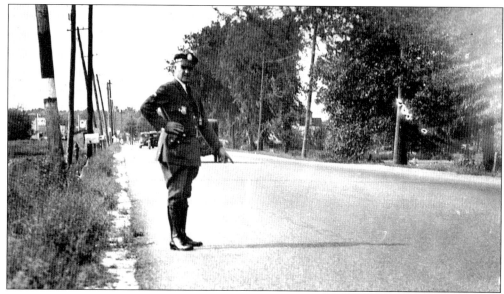

PATROLMAN JACK TRAINOR. Taken on Boston Road in the 1930s, this photograph features Billerica police officer Jack Trainor inspecting the circumstances of an earlier automobile accident. Trainor eventually rose to the rank of chief of police. He retired from the force in 1957. (Courtesy of Tom Paskiewicz.)

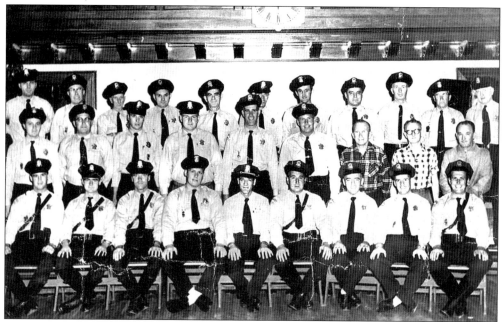

THE BILLERICA POLICE DEPARTMENT. Shown here in the old town hall are members of the police department c. 1955. They are, from left to right, as follows: (front row) Dale Crandell, Joe Dwyer, Joe Burke, Lon Travis, Bob Olivieri, Roger Biagiotti, Bob Honnors, Jim Hamilton, and Bill Fitzgerald; (middle row) Len Buckland, Pete Defoe, John Herring, George Gracie Jr., Jack LeLacheur, Ed Burke, Toastie Morris, Joe Vocell, and Phil Gerrard; (back row) Charlie Fox, Happy Conway, John Terris, Joe Spizio, Archie March, Joe Leary, Stan Paskiewicz, Bill Collins, unidentified, and unidentified. (Courtesy of Tom Paskiewicz.)

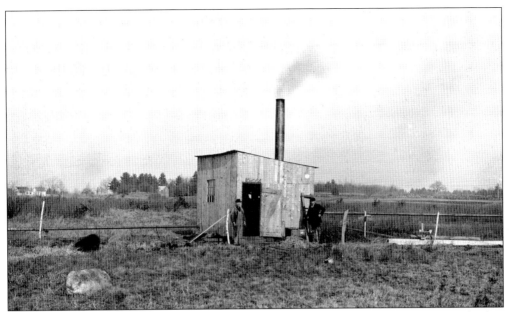

THE BILLERICA WATERWORKS TRIAL PUMPING STATION. Pictured in 1898, this was the first trial pumping station to draw water from wells in the Hutchins Meadow along Boston Road in North Billerica. The engineer outside the station is N.M. Simonds, and there is a Keep Out sign over the door. (Courtesy of the Billerica Museum.)

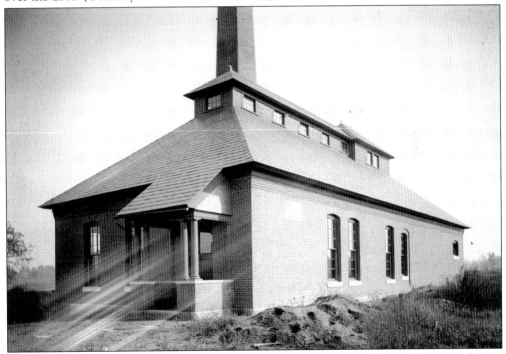

THE COMPLETED PUMPING STATION. Constructed in 1898, this building still exists today on Boston Road behind the waterworks in North Billerica. It was the genesis of the modern water system we have today in Billerica. The granite tablet that adorns the building was installed for $35 when the building was completed. (Courtesy of the Billerica Historical Society.)

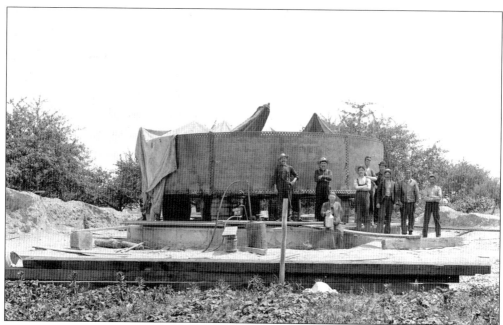

A Standpipe Construction Crew. Located where the current water tower is today near Tower Farm Plaza, the standpipe was built one section at a time, hand-riveted together for strength. This photograph from 1903 shows the initial section elevated on wooden barrels. (Courtesy of the Billerica Historical Society.)

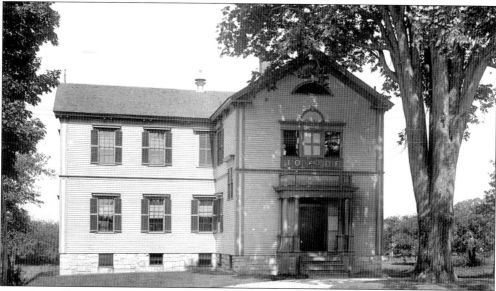

The Odd Fellows Hall. The hall stood on River Street just outside the center. The Shawsheen Lodge No. 64 was granted a charter in February 1842. Initiated in 1845, it was suspended in 1850 after financial hardship. It was reinstituted in 1875, and meetings took place in the Green Hotel until it burned in 1876. The lodge continued at the town hall and above Jasper Bruce's store in the center until 1890, when the Center School became available. It was largely remodeled and became the Gardner Parker Hall. The building burned in 1940. This photograph was taken in the summer of 1903. (Courtesy of the Billerica Museum.)

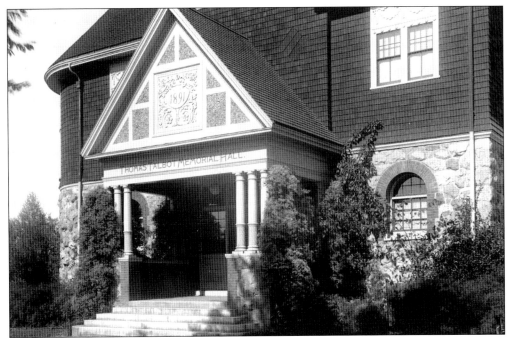

THOMAS TALBOT MEMORIAL HALL. Dedicated on September 7, 1891, Talbot Memorial Hall was a gift by his wife, Isabella White Talbot, to the town in memory of Gov. Thomas Talbot. Designed by architect F.W. Stickney and built with stones quarried on the Talbot estate, the building had several halls that could seat up to 400 people. Standing near where the Boston and Maine depot parking lot is today, it was a social and cultural gathering place for surrounding families. It was razed in the early 1970s. (Courtesy of the Billerica Museum.)

THE REPUBLICAN CLUB. This charming gathering place on Elm Street served as a social club for Talbot and Faulkner Mill workers. It was a place to play cards or become involved in the bowling league and had a recreational focus. This photograph was taken on October 21, 1903. (Courtesy of the Billerica Museum.)

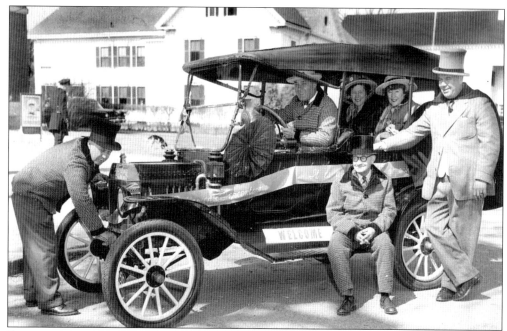

BILLERICA'S TERCENTENARY CELEBRATION. Marcello "Mike" Olivieri, at the wheel of his 1914 Model T touring car, is surrounded by members of the Billerica tercentenary committee. From left to right are Arthur Hallenborg, selectman; Mike Olivieri, town meeting member; Arthur Barnard, chairman of the tercentenary committee; Marion Gould, town moderator; Mildred Westhaver, secretary and town clerk; and Alton Westhaver, chairman of the reception committee. In the background is the Masonic Hall, on Concord Road. This photograph was taken on March 7, 1955. (Courtesy of Beatrice Olivieri Ames.)

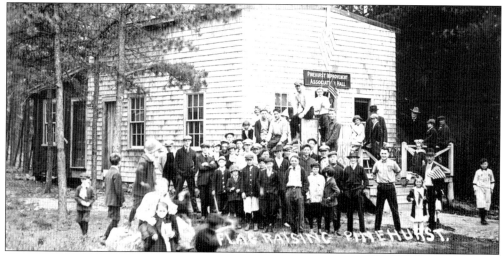

THE PINEHURST IMPROVEMENT ASSOCIATION. The Pinehurst Improvement Association's hall, which served for civic events, fairs, and flag raisings, is pictured here c. 1916. The Pinehurst Improvement Association was one of a number of neighborhood groups that sponsored and worked toward the sensible development of local roads and land. During 1916, masses for St. Andrew's Church were celebrated at the hall, which still stands, somewhat changed, on Boston Road in Pinehurst. (Courtesy of Joseph Shaw.)

Four
BUSINESS AND INDUSTRY

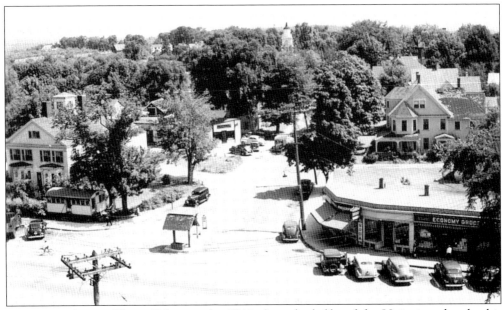

A CENTER AERIAL VIEW. Taken in the 1940s from the belfry of the Unitarian church, this view of the center shows, from left to right, the Faulkner house, with the Billerica Diner on the lawn; L.O. Balch's store, on Andover Road; Woodside's Drug Store; and the Economy Grocery. In the foreground are the town pump and trough. (Courtesy of David D'Apice.)

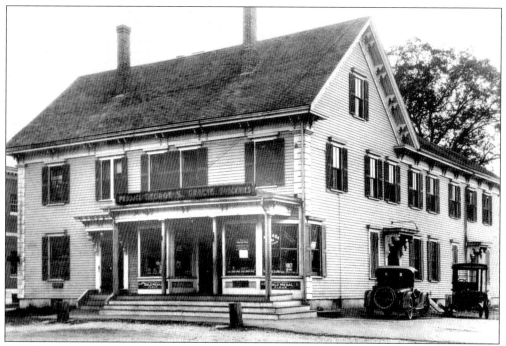

THE GRACIE GROCERY. George S. Gracie's Central Store, located in what is today the Masonic Hall, is shown in the late 1920s. There had been a store in that location for about a century before; previous store owners included Dolan and Fred Morey. (Courtesy of the Gracie family.)

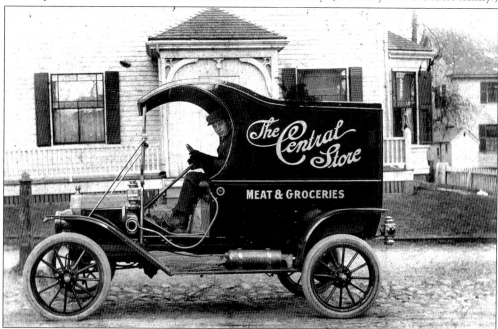

GEORGE S. GRACIE SR. IN THE DELIVERY VAN. George S. Gracie Sr. is shown here *c.* 1912. The van is a Model T Ford, likely purchased in Billerica center, where the small brick building included a Ford dealership that Gracie would come to own later in his lifetime. (Courtesy of the Gracie family.)

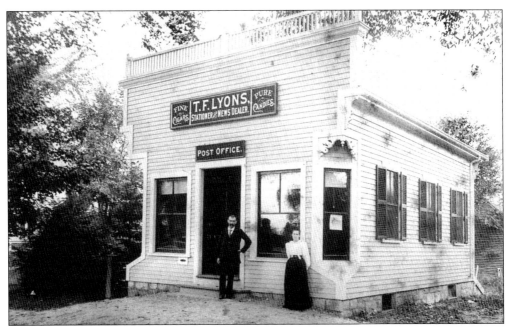

THE LYONS STORE. Thomas Francis Lyons was born in Billerica on March 3, 1865. Pictured here with his wife, Bridget Belle Rogers Lyons, he was postmaster at Billerica center and operated this post office and store on the site of today's Billerica Access Television studio. Lyons lived on Andover Road in the Baldwin house. (Courtesy of Helen Potter.)

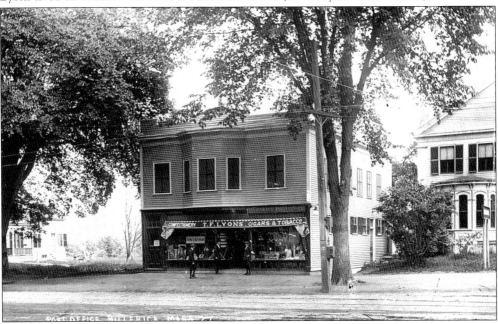

THE LYONS BUILDING. When Thomas Francis Lyons outgrew the small store, he erected this building *c.* 1914 on land that he had purchased from the estate of Luther Faulkner, whose house is pictured on the right. To the left is the home of Marshall Preston, which was built *c.* 1827. Lyons continued as postmaster and operated a candy store, printing business, and rooming house *c.* 1917, when this photograph was taken. (Courtesy of David D'Apice.)

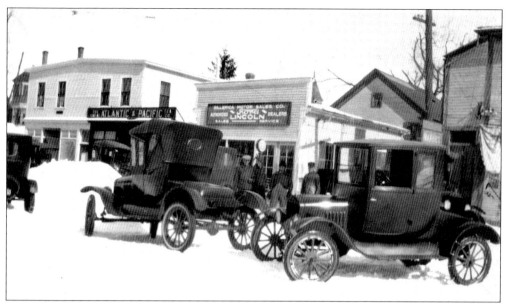

BILLERICA MOTOR SALES. Owned by George Gracie Sr., Billerica Motor Sales was a Ford dealership that offered local farmers a selection of new Model Ts, shown here on arrival from the factory. Eventually, the small dealership, which had been Lyons's store, was replaced with a brick building that is still there today. (Courtesy of the Gracie family.)

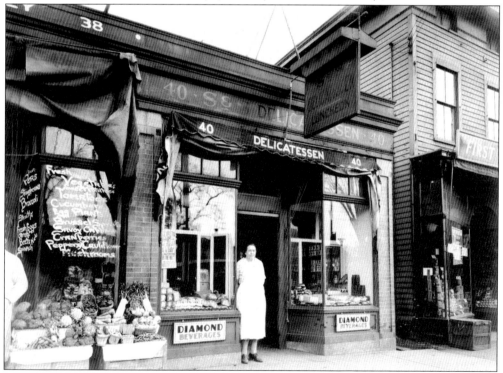

THE S & S DELICATESSEN. Serving lunch and delicatessen cold cuts, the S & S is shown here as it appeared c. 1920. To the right is the First National grocery store. (Courtesy of the Billerica Public Library.)

A COFFEE SHOP. Seen here in the 1940s, this coffee shop served lunch and other meals. (Courtesy of the Billerica Public Library.)

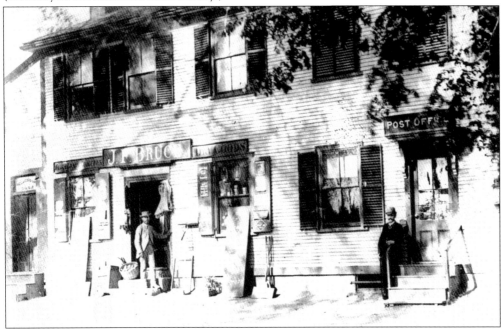

J.F. BRUCE DRY GOODS. Located in what was once the home of Jonathan Bowers on the common, Jasper Bruce's store was one of many in that space. The building is the oldest commercial building still in use in the center. To the right, Thomas Lyons stands outside the post office. This photograph was taken in the late 1800s. (Courtesy of Alec Ingraham.)

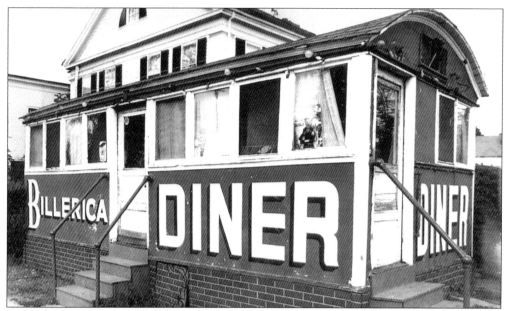

THE BILLERICA DINER. Rolled into place one evening in the 1920s, the Billerica Diner remained on the corner of Boston and Andover Roads until it was removed and destroyed at the Billerica dump in the early 1960s. The iron wheels that this railroad relic traveled on were stored in the front parlor of the Faulkner house. A gathering spot for many local personalities, the diner was the social hub of the center of town. (Courtesy of Jack Horan.)

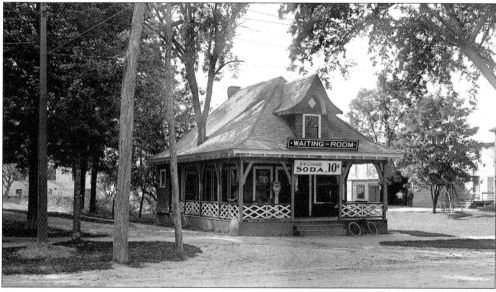

THE WAITING ROOM. Along Boston Road were many places where one could visit a pharmacist, get a drink, or wait for the trolley. This waiting room was operated by Roland Wright, a pharmacist who sold ice cream, soda, and other sundries. Located at the corner of River Street and Boston Road, the building was constructed c. 1901 in the bungalow style, complete with a tree growing through the roof. Today, only the cornerstone pictured here on the left remains. In the distance to the left of this c. 1904 image is the Odd Fellows Hall. (Courtesy of the Billerica Museum.)

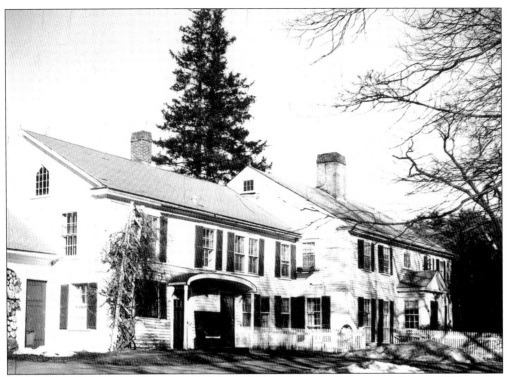

THE KITCHENER FARM. This center-chimney colonial was built by tavern keeper William Tay in the 17th century, just off Lexington Road. In the 20th century, the Kitchener Farm became a dairy-based enterprise where Rosalie Hayden bred prize-winning cattle. The house and barn burned, and the only reminder that remains today is the small stone wall that ran along the front of the property. (Courtesy of Alec Ingraham.)

THE JONES FARM. Billerica's first schoolmaster, Joseph Tompson, erected a house *c.* 1660 on this site, and students were later taught in his home. By 1850, Bernard Tufts was operating a farm here on the lane that still bears his name. Nathaniel Jones and his family lived here in the early part of the 20th century, when the farm encompassed some 135 acres with barns, sheds, a poultry house, and a waterworks. (Courtesy of Alec Ingraham.)

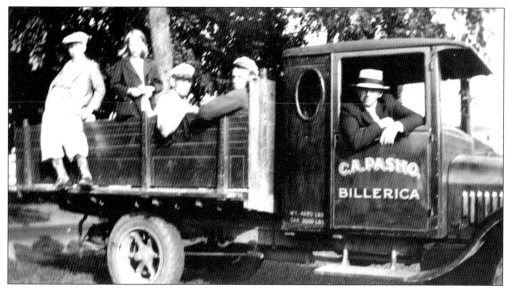

CHESTER PASHO. During the 1920s, Chester Pasho (behind the wheel) operated the Webb Brook Farm, which still exists today on Webb Brook Road. Born in Pinehurst on his father's Civil War–era farm, Pasho sold produce in the Boston farmers' market. From left to right are Robert and Mary Pasho (his children), Willard Gillette, and Eldridge Kinsman on a day trip to Salem Willows. (Courtesy of Mary Pasho.)

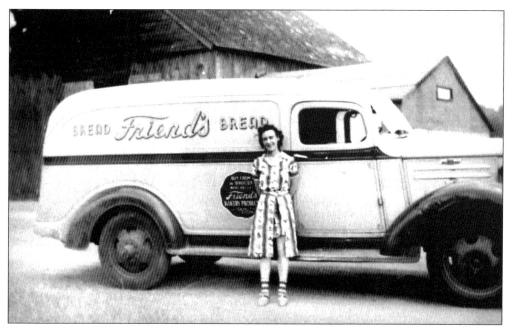

THE FRIEND'S BAKERY TRUCK. Shown on Cook Street in the late 1930s, Helena Flaherty stands in front of the Friend's Bakery truck, which delivered fresh bread and baked goods to local farms. In the background is the Flaherty barn, part of the farm that her family had run since the turn of the century. Eventually, her brother John Flaherty developed a sand and gravel business at that location. (Courtesy of David D'Apice.)

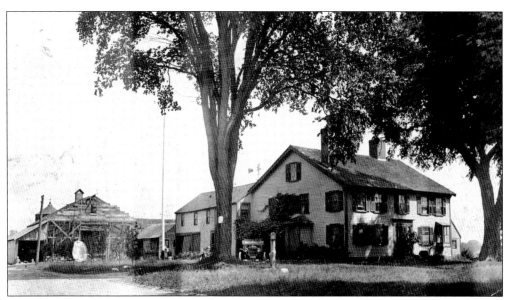

THE MARTIN FARM. Built *c.* 1804, the Bowman Tavern stood on land granted by the king of England in 1687. This photograph was taken *c.* 1910, when the farm was owned by Valentine and Isabelle Martin. The gracious home with barns and silos stood at the junction of Lexington Road and the Middlesex Turnpike, and it offered hospitality to travelers since it was constructed as a stop on the stagecoach route. Today the site is marked by a 99 Restaurant. The original house was razed *c.* 1996. (Courtesy of Eleanor Martin.)

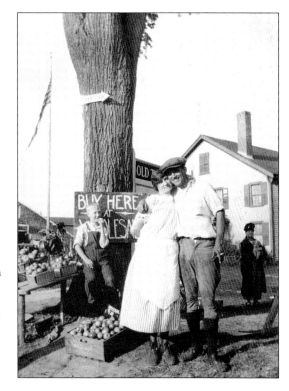

THE MARTIN FARM. Here in front of the tavern are Annie Martin and her son Joe Jr., selling apples and produce to travelers. In addition to the full-scale farming operation, the Martin family ran a restaurant called Martin's Old Tavern Farm, which featured the best dance floor in the area and prize-winning steaks. (Courtesy of Eleanor Martin.)

A NUTTING'S POND ICE CARD. When this card was placed in the window, the ice company would deliver ice to your doorstep, often placing it in your icebox, which was little more than a zinc-lined wooden box. (Courtesy of the Billerica Historical Society.)

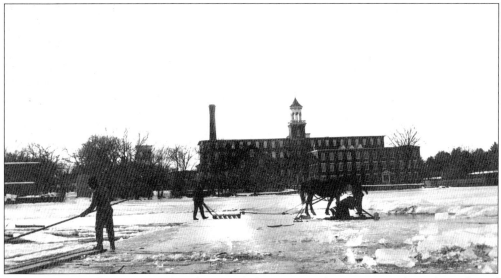

ICE CUTTING. Taken c. 1910, this photograph features men harvesting ice from the millpond on the Concord River in North Billerica. In the distance, one can see the Talbot Mills. The men are using state-of-the-art equipment to secure the blocks of ice. Many blocks were packed in hay and stored in the icehouse of Frederic S. Clark, president of the Talbot Mill. (Courtesy of Alec Ingraham.)

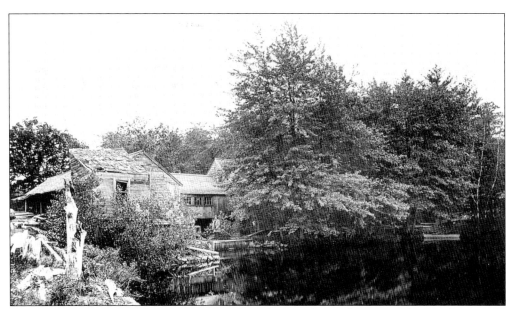

RICHARDSON'S MILL. Although there may have been earlier mills powered by Content Brook, the sawmill pictured here was begun c. 1830 off Gray Street in East Billerica by the Richardson family. Originally a seasonal operation, the milling of timber became year round as demand increased. The partnership of John O. Richardson and William Symmes turned the enterprise into a large-scale lumber business c. 1880. A belt-driven reciprocal saw was powered by the brook, and it was later replaced by a circular blade. In 1910, a decrease in the water supply coupled with a reduced availability of local lumber forced the operation, one of the last water-powered sawmills in Billerica, to close. The mill is no longer extant. (Courtesy of the Billerica Museum.)

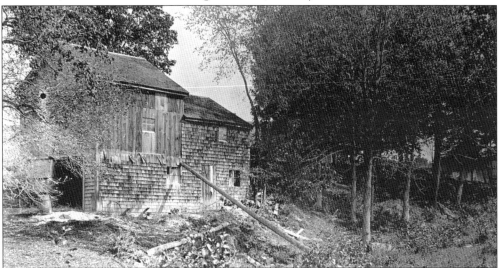

THE JAQUITH GLUE FACTORY. Showing the side of the factory supported by a large wooden beam, this c. 1899 photograph of the Jaquith Brothers Glue Factory was taken by Charles Kohlrausch. It was located between River Street and Concord Road near the Concord River, where waste product was washed away. The factory began c. 1867, and for a short time it became the property of the LePage Company. The building was razed in 1956. (Courtesy of the Billerica Historical Society.)

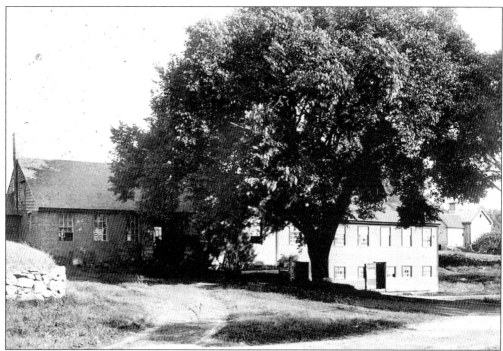

THE HILL MACHINE SHOP. Obtaining the legal rights to produce leather-splitting machinery, Jonathan Hill opened the Hill Machine Shop c. 1830. It stood near the junction of Concord and Dudley Roads and continued in operation until the 1920s. (Courtesy of the Billerica Historical Society.)

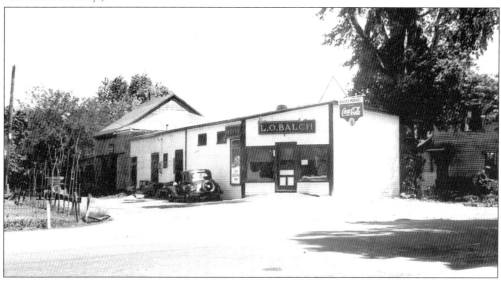

THE L. BALCH HARDWARE STORE. Originally an ell of the Luther Faulkner house (on the corner of Andover and Boston Roads), this building was purchased in 1914 by Fred Morey from the son of Luther Faulkner, Richard. Morey operated a grain business here, with scales installed in front of the building, and eventually he sold out to Leroy O. Balch, who ran a successful hardware store here until c. 1950. Today, the building houses Jim's Barbershop. (Courtesy of David D'Apice.)

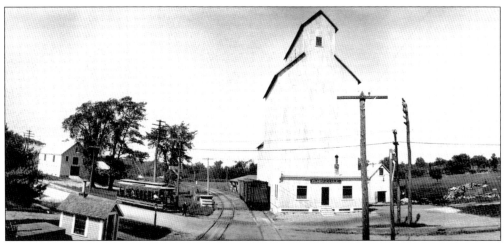

ELMER COLE COAL AND GRAIN. As an agent for Bay State Coal Company, Elmer E. Cole operated this business where the railroad tracks cross Route 3A just north of the center. This photograph includes views of the barn on the left (today the Cricket Shoppe) and the grain elevator. Also shown is the 12-bench open trolley run by the Lexington and Boston Street Railway. The conductor is shown walking ahead of the trolley to ensure safe passage across the track, before the car traveled through the center and down Concord Road toward Bedford and Lexington. The large grain elevator was razed in 1956. (Courtesy of the Cricket Shoppe.)

THE D.J. DEWIRE FAMILY. Based in North Billerica on Billerica Avenue, local mover Daniel J. Dewire was noted for furniture and piano moving. Pictured in front of their home is the Dewire family, including Dewire's son Frank Dewire at the reins of the large wagon. Dewire also delivered wood, coal, and grain. One of the larger clients was the Talbot Mills in North Billerica. (Courtesy of the Billerica Museum.)

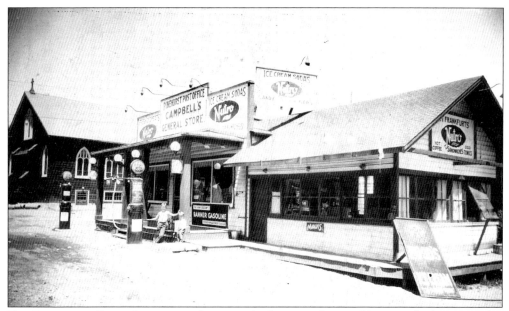

THE PINEHURST POST OFFICE AND CAMPBELL'S GENERAL STORE. Photographed in 1928, this building was owned and operated by James and Mary Campbell. It was located on the corner of Boston Road and Beaumont Avenue. Son Tom Campbell and Joe Campbell Sr. are pictured near the gas pumps, and in the distance, on the left, is the newly built St. Mary's Church in Pinehurst. (Courtesy of Joseph Campbell.)

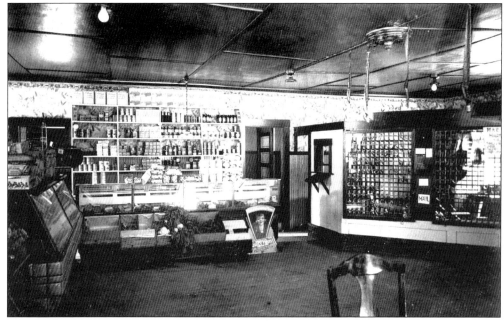

CAMPBELL'S GENERAL STORE. Pictured on the left is the meat case, and at the center are vegetables, cold cuts, and cheese. On the far right is the Pinehurst post office. James Campbell served as the postmaster of Pinehurst from May 1, 1929, to December 21, 1931. The Pinehurst post office was called the Shawsheen post office until its name was changed on May 1, 1929, during Campbell's tenure. (Courtesy of Joseph Campbell.)

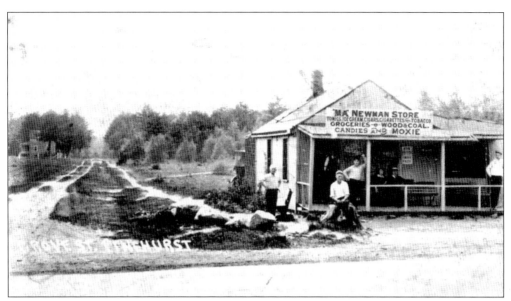

M.A. Newman's. When this business began as a small grocery stop on the corner of Grove Street and Boston Road in Pinehurst, few realized that it would become "Ma" Newman's, a bar and grill that survived into the 1990s before being replaced with a new restaurant. This view from *c*. 1910 shows the sparse population of the area, which was still mainly a summer resort when Maurice A. Newman opened the store. (Courtesy of Paula Jarvis.)

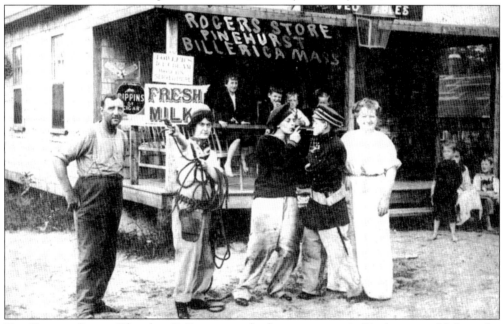

The Rogers Store. Theodore P. Rogers was the first postmaster in Pinehurst, establishing the Shawsheen post office on January 26, 1917. Rogers remained postmaster until 1923, when he was replaced by Harry Brown. This photograph was taken when Rogers owned the post office and small store on the corner of Boston Road and Beaumont Avenue. The cigarette-smoking children and the Wild West–costumed woman toting a gun are unidentified. Today, the building houses Triple L Insurance. (Courtesy of Joseph Shaw.)

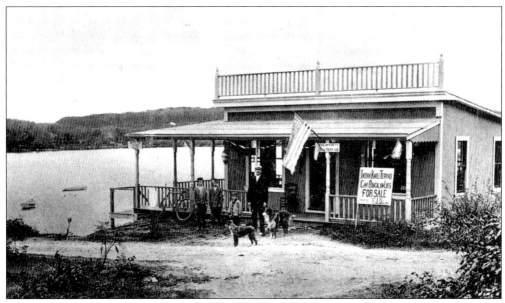

DOLAN'S STORE AND BOATHOUSE. F.J. Dolan was a storekeeper and a dabbler in vacation real estate. From this store, he operated the offices of Indian Knoll Terrace, which offered camp bungalows for sale. He also rented boats and canoes to travelers. This photograph was taken *c.* 1910. The store was located on the western side of the Middlesex Turnpike, where it crosses Nutting's Lake. (Courtesy of Carol Bruyere.)

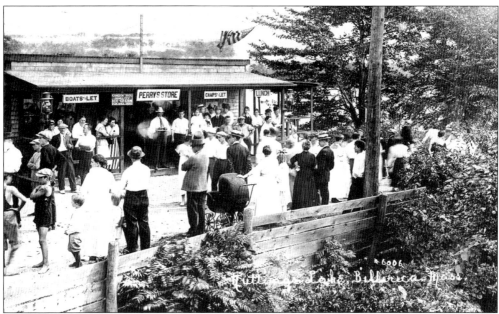

PERRY'S STORE. With boats and camps to let, lunch, and ice cream, this store left little to be desired. It was a tourist hot spot on Nutting's Lake and stood on the eastern side of the Middlesex Turnpike. People would spend hours talking, leisurely surveying the water sports on the lake, and enjoying the country setting that Billerica had to offer. This photograph was taken in the early part of the 20th century. (Courtesy of Jackie Ryan.)

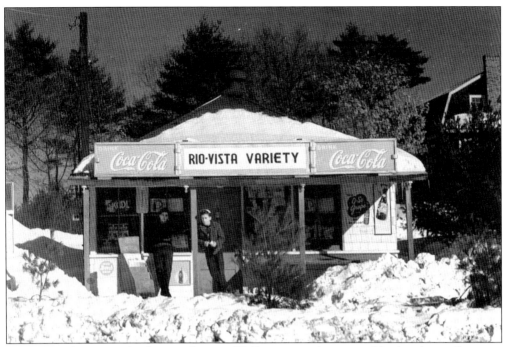

RIO VISTA VARIETY. As the population of Billerica spread into neighborhoods, small variety stores like the Rio Vista Variety sprang up to meet the local need. This store was on Nashua Road in West Billerica. It was for many years operated by Lucio and Adeline Turco. (Courtesy of Dorothy Turco.)

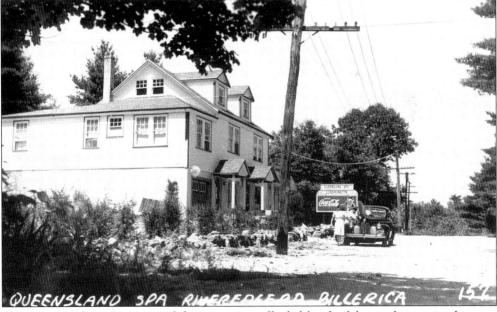

QUEENSLAND SPA. As a part of the recreation afforded by the lakes and rivers in the area, luncheonettes like the Queensland Spa became destinations. Near the Concord River in West Billerica, the luncheonette was on Riveredge Road. This photograph was taken c. 1950. (Courtesy of the Tuttle family.)

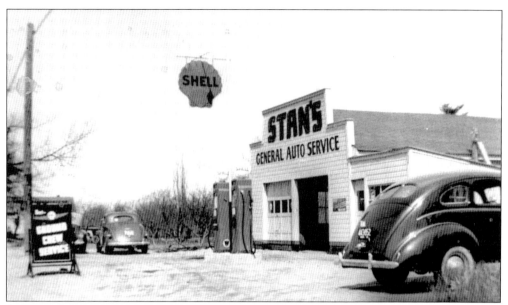

STAN'S GENERAL AUTO SERVICE. At 96 Boston Road in North Billerica, Stan and Julia Paskiewicz opened this station in December 1941. The garage was razed in the 1950s to make way for the building that still houses Stan's Automotive today. The business continues to be family owned and operated. (Courtesy of Tom Paskiewicz.)

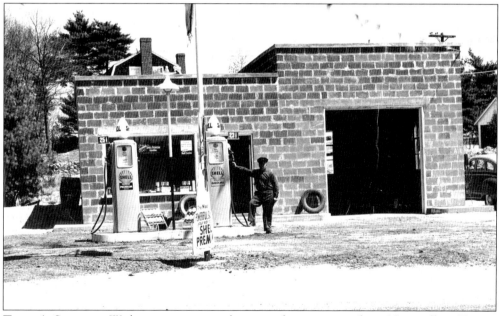

TURCO'S STATION. With its premium gasoline priced as outrageously as 25¢ a gallon, Turco's station stood just to the right of the Rio Vista Variety store on Nashua Road in West Billerica. This photograph dates from c. 1950. (Courtesy of Dorothy Turco.)

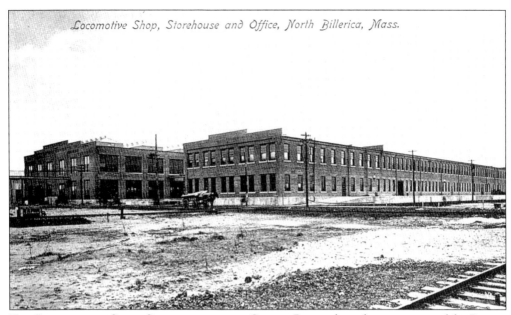

Locomotive Shop, Storehouse and Office, North Billerica, Mass.

THE LOCOMOTIVE SHOP, STOREHOUSE, AND OFFICE. Pictured are the operations of the Boston and Maine Car Shops, where engines were built and repaired in North Billerica. This photograph dates from *c.* 1914. The shops were located in what is now called Iron Horse Park, off High Street. (Courtesy of Tom Paskiewicz.)

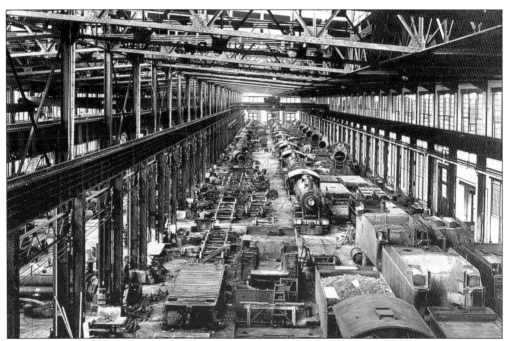

BOSTON AND MAINE REPAIR SHOPS. This interior view of the shops, which opened in 1914, was taken in the early 1920s. Pictured are a number of cast-iron, large-scale engines in various stages of disassembly. Although no longer in use for steam locomotive repairs, numerous buildings are still extant. (Courtesy of David D'Apice.)

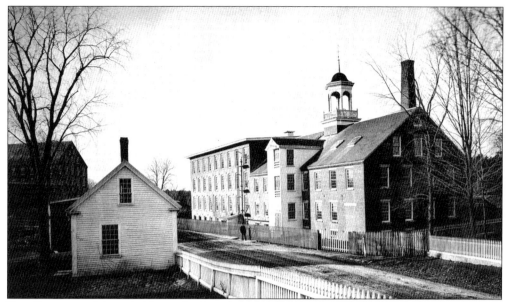

THE FAULKNER MILL. A fifer in the Revolutionary War, Francis Faulkner had already opened a number of small mills and a chocolate company when he leased the secondary water rights for a mill in North Billerica from the Middlesex Canal Company. In 1811, he built the first mill where he specialized in "satinet" and flannels. The Faulkner Mill passed to Faulkner's oldest son, James Robbins Faulkner. It was renowned for its cloth manufacturing until *c.* 1987, when the operation closed. Faulkner Street passes in front of the mill in this *c.* 1880 photograph, one of the earliest known images of the mill before its tower and cupola were completely rebuilt of brick. (Courtesy of Charles Kennelly.)

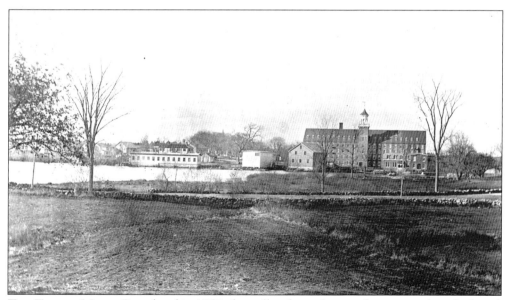

THE TALBOT MILLS. Completed in 1857, the mill is shown here with its original pitched roof. Principally engaged in the manufacture of woolen goods, the enterprise was founded by Charles and Thomas Talbot. It continued in operation until 1963. (Courtesy of the Billerica Museum.)

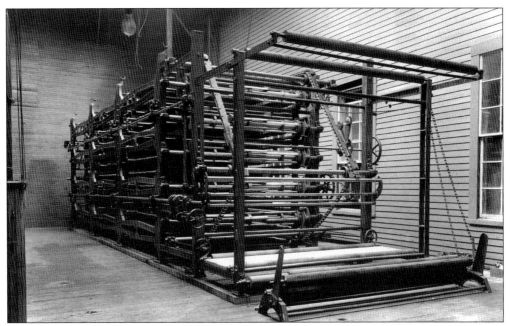

HEATHCOTE DRYER. John Heathcote and Son manufactured commercial-scale mill equipment in England. The new carbonizing dryer is shown being installed at the Talbot Mills on November 6, 1907. (Courtesy of the Billerica Museum.)

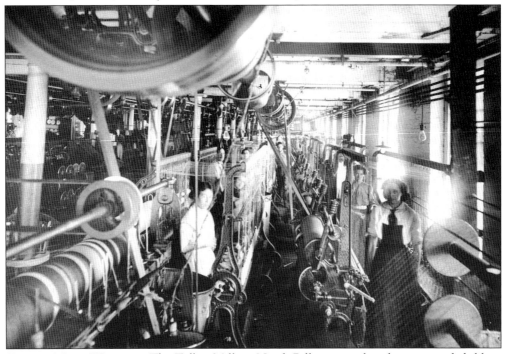

TALBOT MILLS WORKERS. The Talbot Mills in North Billerica employed women and children who were mostly immigrant labor. This *c.* 1890 scene shows the inside of the mill. The large windows allowed light into the shops, and the workday could be extended during peak production periods. (Courtesy of the Billerica Historical Society.)

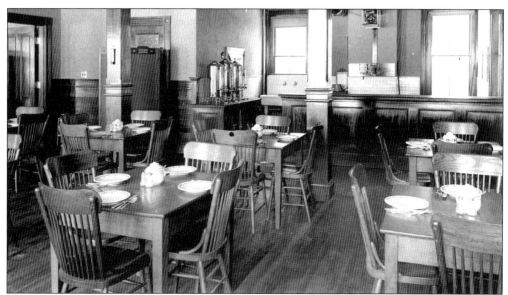

THE TALBOT MILLS LUNCHROOM. The lunchroom at the mills, outfitted with chairs, silverware, and ironstone plates, is shown here. There was a large fireplace at one end of the room, restrooms in the center, and urns for coffee and tea near the service counter. A porcelain sink is in the back corner. This photograph was taken on March 6, 1907. (Courtesy of the Billerica Museum.)

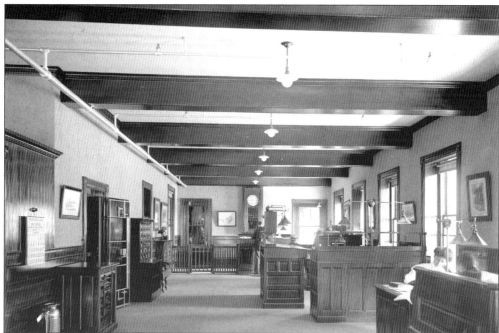

THE TALBOT MILLS MAIN OFFICE. With its gigantic walk-in safe on the left and master time clock on the back wall, this was the scene inside the main office at the mill. Standing in the back is John Kinlan. Wearing a straw hat, Howard Haden sits with his back to the viewer. Delloris Foster is at the desk on the right, and Albert Richardson is facing her. This photograph was taken on August 16, 1907. (Courtesy of the Billerica Museum.)

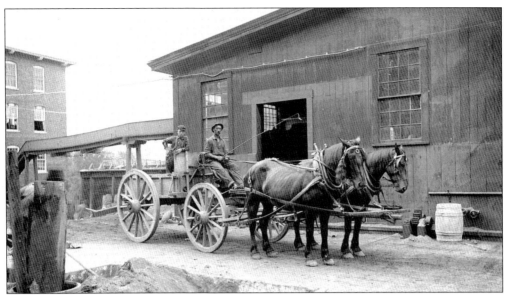

THE TALBOT MILLS LOGWOOD TEAM. Taken in 1898, this photograph features the two-horse logwood team from the Talbot Mills in North Billerica. (Courtesy of the Billerica Museum.)

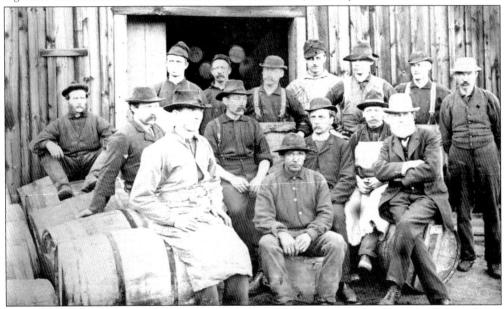

THE TALBOT DYEWOOD AND CHEMICAL WORKS. C.P. Talbot began grinding dyewood in a mill on the west bank of the Concord River in 1839. He was soon joined by his brother Thomas Talbot, and the enterprise was relocated several times. It was finally moved to a location off Rogers Street near the Middlesex Canal. Pictured here are the workers of the company in 1883. Among the group is Charles Kohlrausch (with derby and mustache, seated just right of center), who was the superintendent of the group for a number of years. By 1908, the use of coal tars began to replace the need for dye woods, and the production at this facility was limited mostly to sulfuric acid. As early as 1914, chemicals were no longer manufactured. Attempts to revitalize the business by other interests failed. The site of numerous fires, the buildings were removed by 1927. (Courtesy of the Billerica Historical Society.)

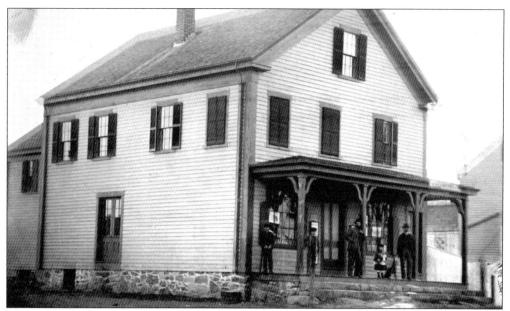

THE JONES AND FOSTER STORE (LATER ELWOOD'S). Located where Elm Street and Wilson Street meet, this store was photographed and captured on a tintype *c.* 1870. The building appears to have just been built, and there are a number of patrons on the porch. The store supplied mill employees with groceries and sundries at a time when most of them had no transportation other than by foot. This building was razed sometime after 1963. (Courtesy of the Billerica Historical Society.)

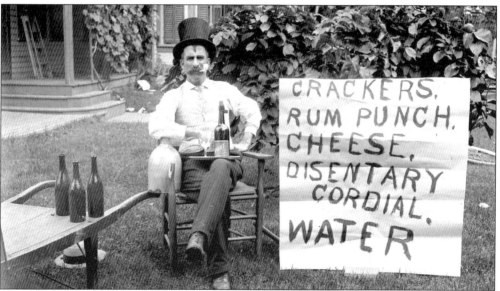

HERBERT W. SHELDON. Shown *c.* 1903, Herbert Sheldon takes a few moments to enjoy the afternoon. Sheldon was influential in electrifying the Talbot Mills, and as an engineer, he worked to develop running water and sewer in North Billerica. His foresight teamed him up with photographer Nat Hutchins, and together they created the 1,100-glass-plate negative collection at the Billerica Museum. Among the irreplaceable images is this is one, which clearly reflects Sheldon's sense of humor. (Courtesy of the Billerica Museum.)

Five

HOMES

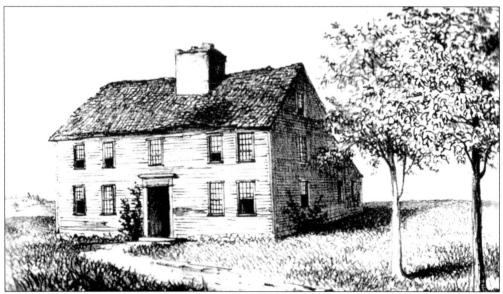

THE JONATHAN DANFORTH HOUSE. One of the earliest settlers of Billerica, Jonathan Danforth lived in this garrison house just to the northwest of the common. Built by 1676 by the prominent surveyor, the house was razed *c*. 1885. The well that supplied him with water remains to mark the approximate location of his homestead. (Courtesy of Alec Ingraham.)

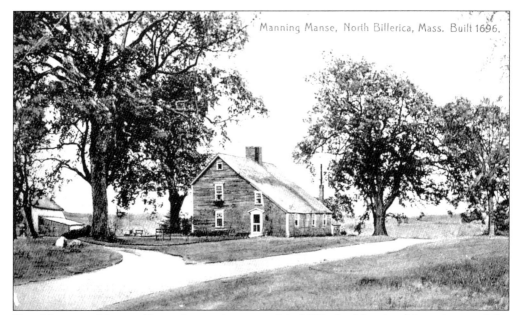

Manning Manse, North Billerica, Mass. Built 1696.

THE MANNING MANSE. Shown here as it appeared in 1907, the Manning Manse is one of the oldest surviving wood-framed structures in Billerica. It was built in 1696 in what was then just wilderness. The sturdy garrison saltbox remains today on Route 129 near the Chelmsford town line. Partially damaged by fire in the mid-1990s, the Manning Association received one of 13 preservation awards in 1997 for its efforts in restoring the house. (Courtesy of David D'Apice.)

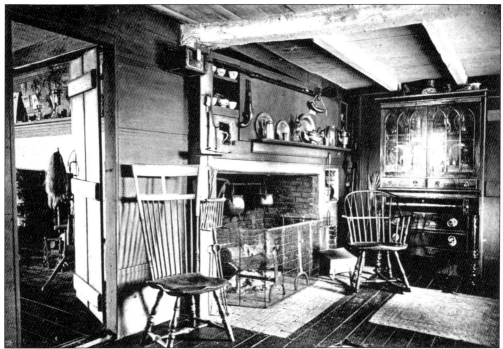

THE MANNING MANSE LIBRARY. Complete with sack-back Windsor chairs and period furnishings, the Manning Manse library is shown here as it appeared c. 1915. In 1983, the Manning Manse was listed on the National Register of Historic Places. (Courtesy of David D'Apice.)

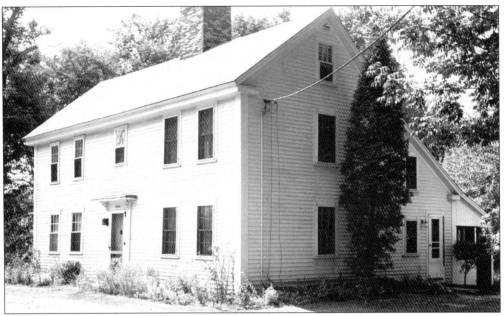

THE FARLEY GARRISON. Attributed to Abraham Jaquith at the time of his marriage to Hannah Farley in 1725, this garrison saltbox was listed on the National Register of Historic Places as the result of a thematic study. Commonly believed to have been built much earlier than the date assigned by the study participants, the house was recently disassembled and removed to New Hampshire. (Courtesy of the Billerica Historical Society.)

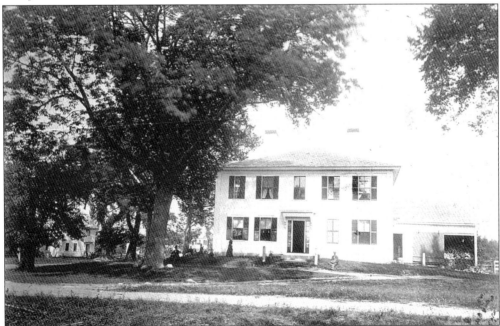

THE JAQUITH HOUSE. Marking the corner of the Middlesex Turnpike and Concord Road is the Jaquith house. The house is pictured c. 1880, when the Jaquith Brothers operated a glue factory on the Concord River. This classic hip-roofed home was built c. 1812 and still stands today. On the left in the distance is the Farley garrison. (Courtesy of the Billerica Historical Society.)

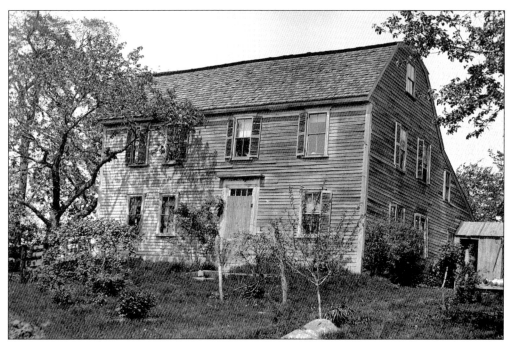

THE EBENEEZER BRIDGE HOUSE. Built in the early 18th century, this house is the only known gambrel-style Colonial still standing in Billerica. At one time, it was said to have been the home of Maj. Gen. Ebeneezer Bridge, who was court-martialed and found innocent of surrendering at Bunker Hill. The house stands today at the end of Farmers Lane. This photograph was taken in the late 1800s, when the Farmer family lived there. (Courtesy of the Billerica Historical Society.)

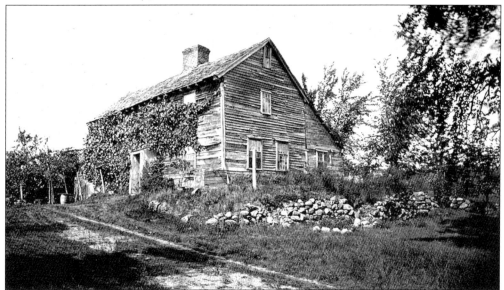

THE FRENCH GARRISON. During a Native American attack in 1675, local families fled to the garrison house of Jacob French for protection. This photograph shows the house as it appeared in 1899, covered in vines. The garrison is thought to have been located on Allen Road, although no clear reference is available. (Courtesy of the Billerica Historical Society.)

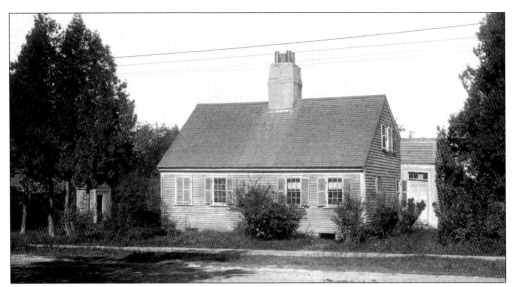

THE SABBATH DAY HOUSE. Built in the mid-18th century by a group of families needing shelter from the winter winds on the sabbath, this sturdy house still remains on Andover Road. Regular attendance in church was a requirement for freemen to vote, and because travel over distance was impractical, a nearby gathering place was created for midday respite and refreshment. David Osgood leased the land to J. Patton, J. Baldwin, R. Kendall, J. Manning, Lt. W. Manning, T. Danforth, and their families for the construction. They were called "the Proprietors" until 1818, when the house was no longer used as intended. Theophilus Manning bought out the interests of the others. It is seen here c. 1907. (Courtesy of the Billerica Museum.)

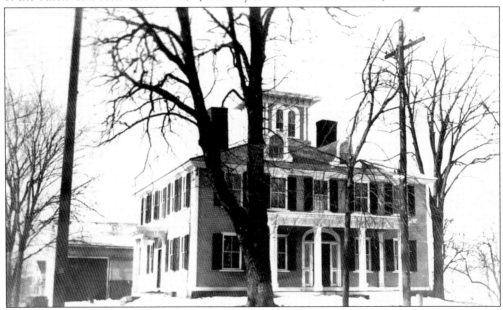

THE JUDGE JOSEPH LOCKE HOUSE. Built c. 1811, this hip-roofed home has taken a number of forms over the years. Shown here c. 1910 with dormers and cupola added c. 1870, it stands today north of the common on Boston Road. Joseph Locke was born in New Hampshire in 1772 and began his legal practice in Billerica in 1801. In 1833, he moved to Lowell, where he became a judge in the police court. (Courtesy of Alec Ingraham.)

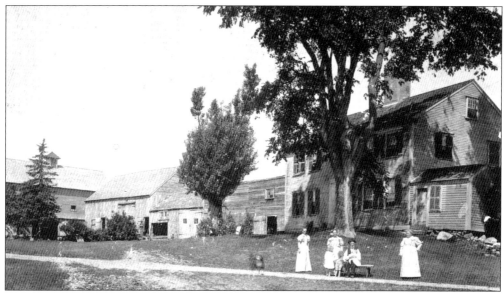

THE WEBB BROOK CLUB. Constructed in 1739 by the Richardson family, this home was built on a land grant from the king of England. Pictured here *c.* 1880 and known locally as the Webb Brook Club, the home served as a tavern for generations, before being leveled *c.* 1995. Once the site of a restaurant, club, golf course, and driving range, the house and barns stood on the corner of Allen and Webb Brook Roads. (Courtesy of Paula Jarvis.)

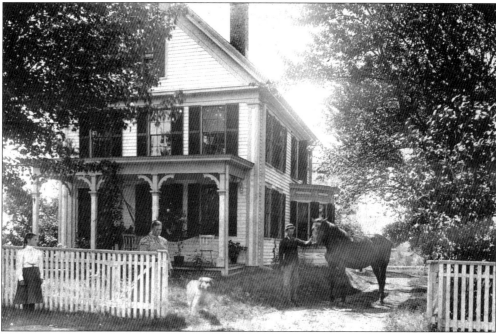

THE MOORE HOMESTEAD. Photographed by the itinerant Howes Brothers photography team in 1899, the Moore home, with Fred Moore and his horse to the right, is seen here. To the left are members of his family, including Moore's mother, younger sister, and dog. No longer in existence, the farm stood near the junction of Webb Brook and Allen Roads, on the south side of Webb Brook Road. (Courtesy of Mary Pasho.)

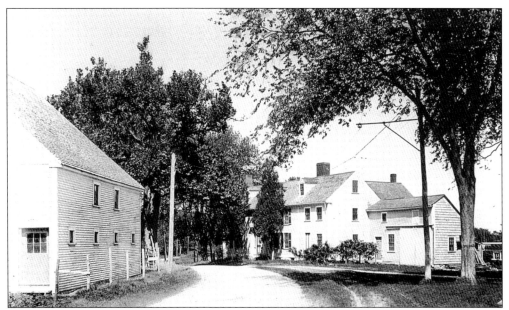

THE ALLEN TAVERN (LATER KING'S TAVERN). Built *c.* 1740 on the Salem Road in East Billerica, the Allen Tavern still stands today. It was originally a stagecoach stop where travelers heading toward Salem, Massachusetts, or New Hampshire could pause from the long journey. In addition, it also served as a tavern for passengers on the Middlesex Canal. The intersection is sometimes known as King's Corner. The barn pictured on the left is no longer standing. This photograph was taken *c.* 1920. (Courtesy of the Billerica Historical Society.)

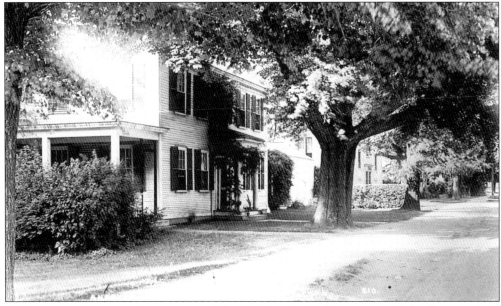

THE BALDWIN HOUSE. Generations of the Baldwin family have occupied this house, which was built between 1810 and 1811. Located just east of the center on Andover Road, the house still stands today. The original home of gentleman Capt. John Baldwin and subsequently of postmaster T.F. Lyons, the home features murals painted by noted local artist Rufus Porter. At one time, it housed the first telephone switchboard in Billerica. (Courtesy of Tom Paskiewicz.)

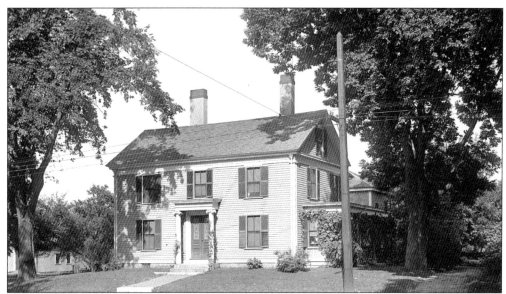

THE MARSHALL PRESTON HOUSE. Built in 1827 by the young attorney Marshall Preston, this home still stands on Boston Road and served as the parsonage of the Unitarian church from 1881 to 1960. Among other offices he held, Preston served as the town clerk, postmaster, selectman, and trustee for a number of estates. He moved to Lexington in 1849. Luther Faulkner purchased the house in 1880, and it was completely renovated to serve as the Unitarian parsonage. (Courtesy of the Billerica Museum.)

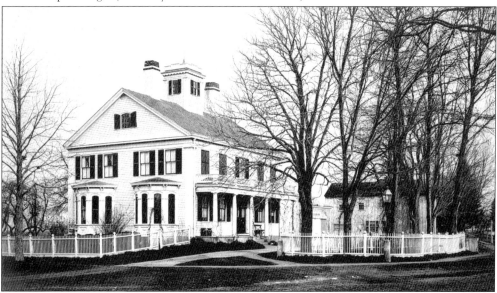

THE THADDEUS BROWN HOUSE. When Thaddeus Brown married Susannah Crosby in 1832, he built this home on the corner of Andover and Boston Roads, where he shared a medical practice with Dr. Zadok Howe. When Brown died unexpectedly in 1839, Howe continued the practice alone until his death in 1851. The trustees of his estate sold the property to Luther Faulkner in 1855. Luther and Martha Faulkner "Victorianized" the house to the appearance it has today, adding a caretaker's apartment and the distinctive bay windows on Boston Road. (Courtesy of Charles Kennelly.)

80

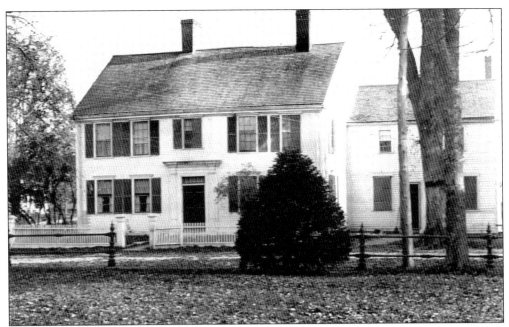

THE PARKER-RICHARDSON-DICKINSON HOUSE. Built *c.* 1750, this home stood on the south end of the Billerica common where Cumings Street meets Boston Road, before it was removed in 1894 to make way for the present Dickinson house, built the following year. (Courtesy of the Billerica Historical Society.)

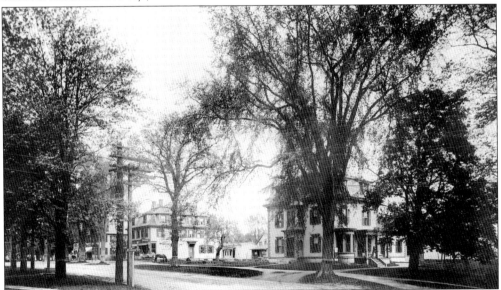

THE BULL HOUSE AND STORE. Looking north on May 31, 1907, this view shows the intersection of Cumings Street and Boston Road. In the distance behind the trees is the home and store of Jasper F. Bruce (today the Center Cafe). To the right, the first of the two mansard-style buildings is the store of Sydney A. Bull. He lived in the adjacent house, which was built *c.* 1873 by Paul Hill, known for his engineering on the Hoosac Tunnel project. The house was moved farther north on Route 3A to make way for the Commons Plaza, now O'Connor Hardware Plaza. (Courtesy of Arthur Giles.)

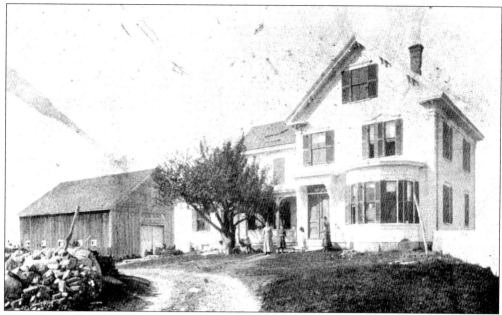

THE MARTIN LANE FARM. Located on River Street where the senior housing complex is today, the Martin Lane farm is shown here *c.* 1875 with the family out front. Shown are Bridget Lane and her three daughters, Mary, Annie, and Catherine Lane. The barn burned in 1955, and the home was demolished in 1967. (Courtesy of Charles Kennelly.)

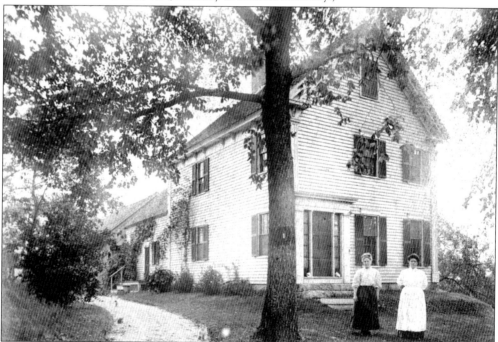

THE MCDERMOTT HOUSE. Taken in the early 1900s, this photograph features the home of the McDermotts, on Charnstaffe Lane. Originally built *c.* 1850 by Stephen Winter, the house still stands today. Pictured in the front are Frances McDermott, born in 1886, and her mother, Alice Grady McDermott. (Courtesy of Mary Pasho.)

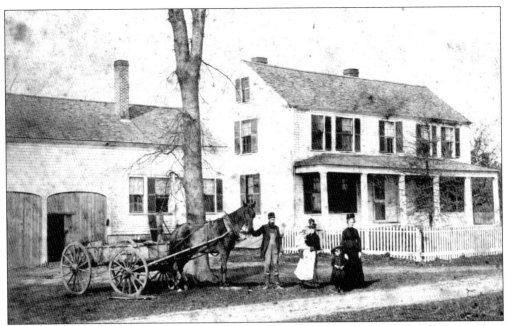

THE OLD SHELDON HOMESTEAD. Built long before 1853, the old Sheldon homestead on Sheldon Street was demolished c. 1965. Pictured here in the front are James McDermott and his wife, Alice Grady McDermott, holding their baby daughter Frances McDermott. This photograph was taken c. 1887. (Courtesy of Mary Pasho.)

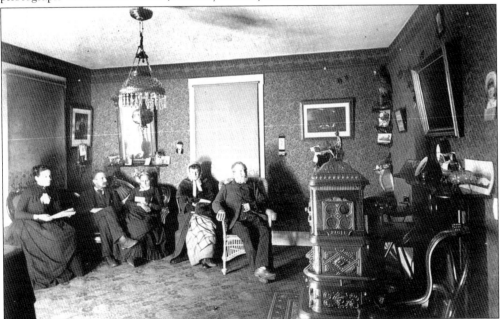

THE KOHLRAUSCH PARLOR. Pictured here are, from left to right, Lillian Kohlrausch; her husband, Charles Kohlrausch; his mother, Hannah Kohlrausch; his sister Hannah Kohlrausch, and his father, Charles Henry Kohlrausch. The photograph was taken sometime before 1895 in their North Billerica home. In the foreground is an ornate parlor stove. (Courtesy of the Billerica Historical Society.)

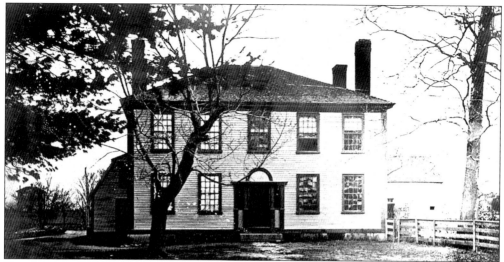

THE ROGERS HOUSE. William Rogers built this fine brick-end house *c.* 1807, removing an earlier home that was built by Roger Toothaker. The ell to the left of this house, however, was reused from the previous house, which was the site of a vicious Native American ambush in 1695. During the attack, Toothaker's wife was killed. Their daughter fled into the woods, hiding in a well. The ell was removed in 1898, and the home became the property of the Calvin Rogers family, who sold it to the Talbot Mill for use as a tenement house. The house, one of the few brick-enders in Billerica, still stands on Rogers Street. (Courtesy of the Billerica Historical Society.)

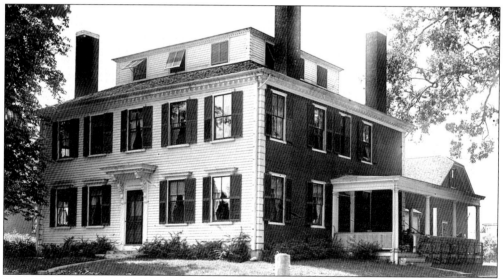

THE WILLIAM BOWERS HOUSE. Dr. William Bowers was born in Billerica in 1744, and he graduated from Harvard College in 1769. He purchased land from the estate of Samuel Ruggles and built this home in 1804. Occupied by the eccentric but philanthropic Bowers sisters (Priscilla, Fanny, and Mary), who lived there until the last of them died in 1871, the house was rumored to have a secret room built to hide the occupants during the War of 1812. On the corner of River Street and Boston Road, the home remains largely unaltered. This photograph was taken in 1903, when the house was owned by Rev. Minot J. Savage. (Courtesy of the Billerica Museum.)

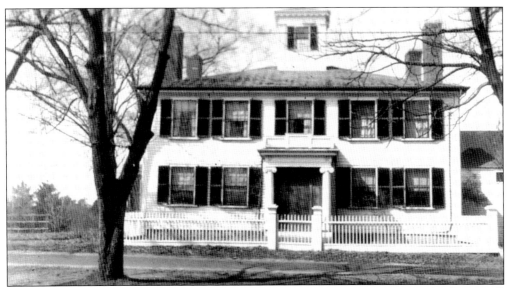

THE OLIVER FARMER HOUSE. Built in 1803 by the successful Oliver Farmer, this house still stands in North Billerica where Elm Street meets Colson Street. The large barns that were to the right of the home have been removed over the years, but this brick-ender retains much of its original character. For many years, it was owned by Israel Colson, who married Oliver's daughter Rachel Farmer. Colson was long employed by the proprietors of the Middlesex Canal. He is known for building the Red Locks. (Courtesy of Alec Ingraham.)

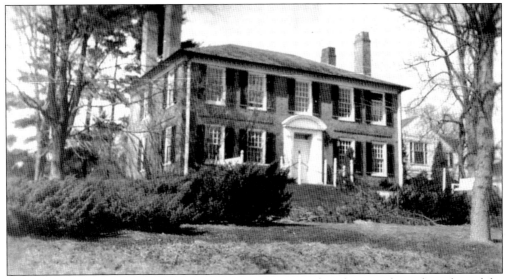

THE ABNER STEARNS-PICKMAN HOUSE. Taken *c.* 1920, this photograph is of another of the Billerica brick-enders, the Abner Stearns-Pickman house. Constructed in 1798 entirely of brick laid in Flemish bond, it was one of the most impressive of the Federal-style houses built in Billerica. The property overlooks a broad meadow leading to the Concord River via a series of terraces and is still visible today. (Courtesy of Alec Ingraham.)

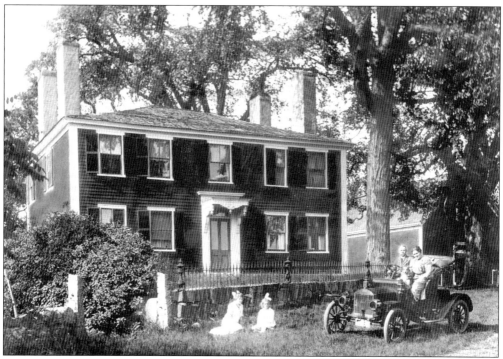

THE CROSBY HOUSE. This brick-end house at the corner of Manning Road and Middlesex Turnpike was built by Seth Crosby in 1804. Pictured *c.* 1915 in a two-seater runabout is the Raymond Fiske family. It is interesting to note that the automobile was a right-hand drive. The house and barn were razed in the 1970s. (Courtesy of Eleanor Martin.)

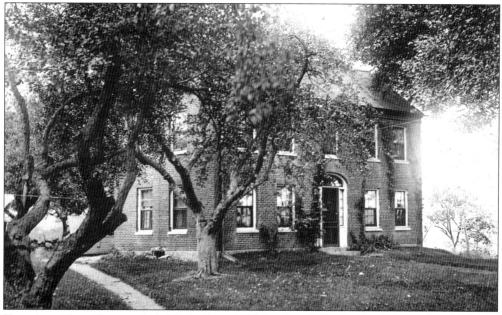

THE ASA HILL HOUSE. Probably built *c.* 1825 by Asa Hill, this brick home has been the Kennelly farm for nearly a century. Its early masonry style is unusual for a Billerica farmhouse. The house is located on North Road off Treble Cove Road. (Courtesy of Charles Kennelly.)

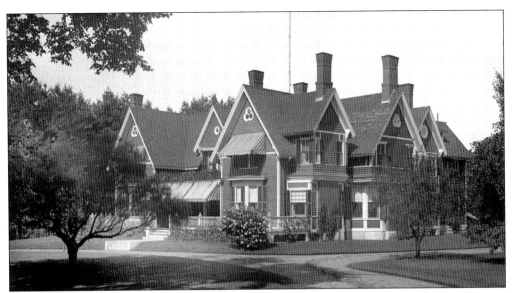

THE RED GABLES. Frederic S. Clark's residence is shown in August 1903. As treasurer, superintendent, and later president of the Talbot Mills, and the first water commissioner for Billerica, Clark played a crucial role in the development of the modern water and sewer system in town. The Red Gables, located on Mount Pleasant Street in North Billerica, still stands today. (Courtesy of the Billerica Museum.)

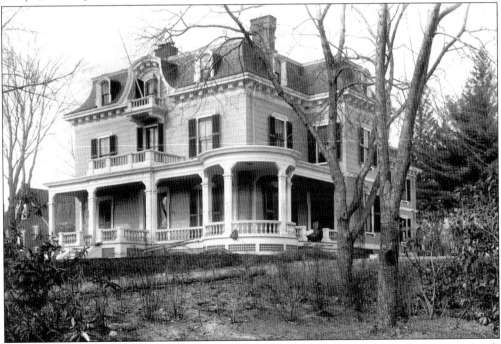

THE THOMAS TALBOT RESIDENCE. Shown here on April 20, 1906, is the attractive mansard-style residence of Thomas Talbot. He, along with his brother Charles, owned the North Billerica woolen mills that bore their name. In 1878, Thomas Talbot was elected governor of Massachusetts. This house, which was located on Mount Pleasant Street in North Billerica, is no longer extant. It was razed c. 1940. (Courtesy of the Billerica Museum.)

THE MIDDLESEX TAVERN. Seen in June 1907, the Old Tavern Block was built c. 1815 by Nathan Mears at the junction of Elm and Wilson Streets in North Billerica. The large wing to the left was added c. 1833. The building housed a store and rooms for newcomers to the area. Many local social events were held there, including the wedding reception of Edward Talbot, the nephew of Governor Talbot. The large wing was removed after a fire in 1934. The right portion of the building remains today. (Courtesy of the Billerica Museum.)

WILSON STREET. This undated photograph shows Wilson Street before water and sewer were installed and the road was improved. The children of mill workers are seen here gathering in the street, and mill duplexes, some of which are still there to this day, line the dirt road. Many of the houses were moved back from the road to allow for water and sewer lines during construction in the late 1800s. (Courtesy of the Billerica Historical Society.)

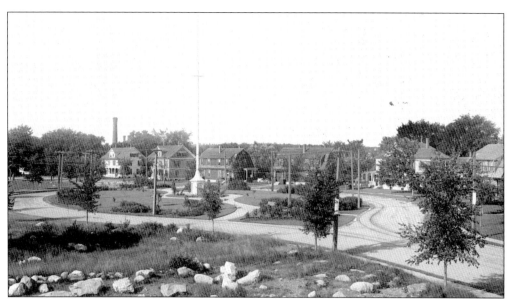

THE TALBOT OVAL. Taken from a Talbot School window on July 26, 1904, this view shows the Talbot Oval in North Billerica, complete with flagpole and trolley tracks. One of the Talbot Mill properties, the oval was the pride of the neighborhood and was mostly surrounded by mill houses. Designed by landscape architect Warren Manning, the gardens and paths were meticulously maintained. The oval is visible today on Talbot Avenue. (Courtesy of the Billerica Museum.)

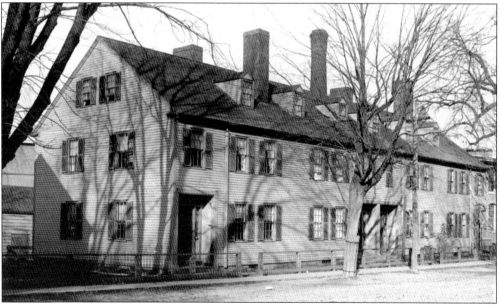

THE CANAL BLOCK. This building is shown here as it appeared at the beginning of the 20th century. It is attributed to Levi Wilson, who presumably erected it for the proprietors of the Middlesex Canal c. 1833. Located next to the Talbot Mills repair shop on Elm Street, it provided housing for mill and canal workers. After his marriage to his second wife, Isabella Hayden, in 1855, Governor Talbot and his new bride lived in one of these apartments for a brief time. The building was burned c. 1984. (Courtesy of the Billerica Museum.)

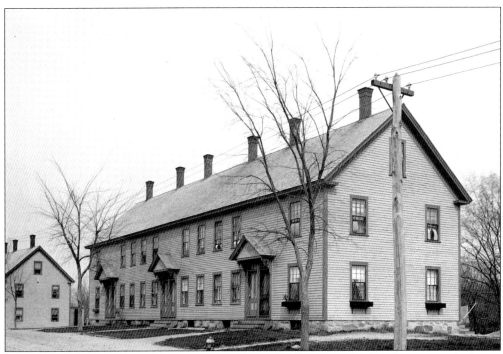

THE HOUSE AT 80–90 WILSON STREET. In 1903, this house in North Billerica was the home of a number of mill workers and their families. (Courtesy of the Billerica Museum.)

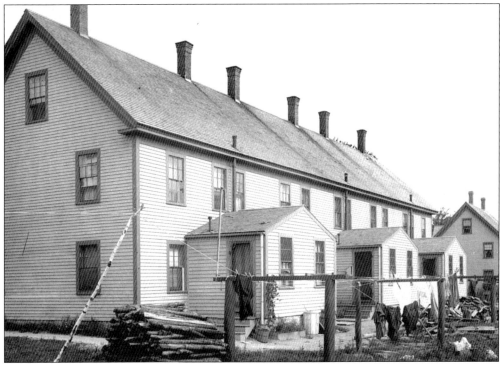

THE HOUSE AT 68–78 WILSON STREET. Photographed in 1903, another of the mill houses is shown, complete with laundry hanging in the backyard. (Courtesy of the Billerica Museum.)

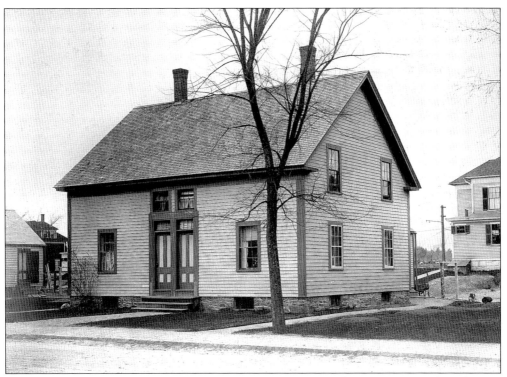

A Talbot Mills Employee Cottage. Built as duplexes, employee cottages such as the one shown here once offered inexpensive housing for the many immigrants who populated the area, all employed by the Talbot Mill. This photograph is from the beginning of the 20th century. (Courtesy of the Billerica Historical Society.)

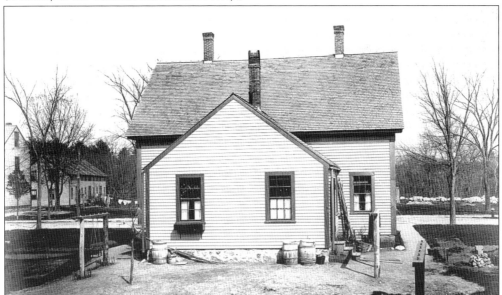

An Employee Cottage. This view shows an employee cottage from the back. Visible are a hammock, a swing for a child, barrels, buckets, and clotheslines. (Courtesy of the Billerica Historical Society.)

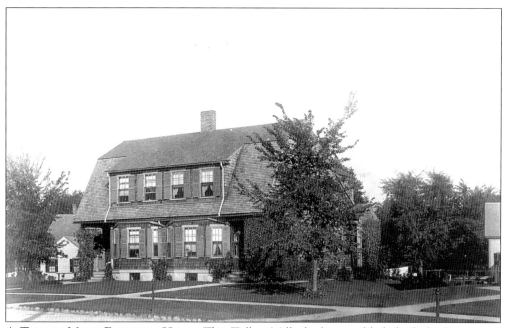

A TALBOT MILLS EMPLOYEE HOME. This Talbot Mills duplex was likely built for foremen or overseers. Complete with flower gardens and manicured lawns, these houses were the scene of annual gardening contests, with coveted prizes awarded to the families with the best-kept grounds, window boxes, and gardens. (Courtesy of the Billerica Historical Society.)

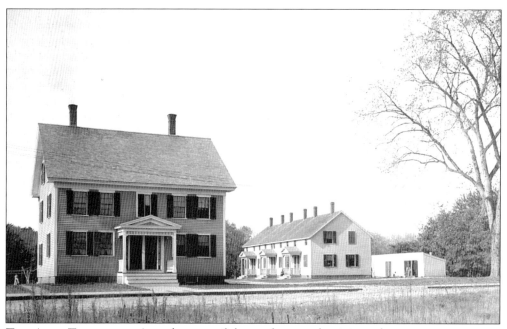

THE ACRE TENEMENTS. A predecessor of the modern condominium, these tenements were a way of concentrating the living space and creating super-efficient housing for the mill workforce. This photograph was taken in 1907 at a location off Rogers Street, now Millstone Way, and the tenements have remained there to this day. (Courtesy of the Billerica Historical Society.)

Six

SCHOOLS AND LIBRARIES

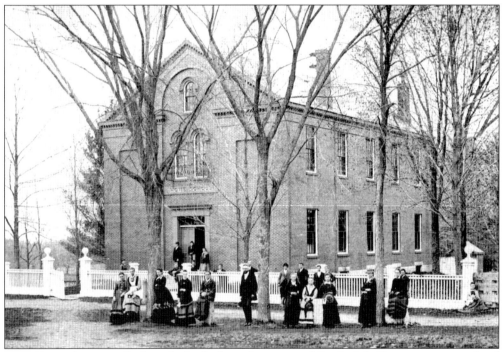

THE HOWE SCHOOL. Built with funds from the estate of Dr. Zadok Howe, prominent local physician, the Howe School was intended as an academy of higher learning controlled by a board of trustees named by Howe. Local architect Daniel Bean was chosen to design the building, which was located on the "Everett lot," likely purchased from the Ichabod Everett farm. Constructed in 1852, this brick Greek Revival structure still stands on Boston Road. Originally made up of one room downstairs and one room upstairs (both of which were heated by wood stoves), the building underwent a number of improvements in the late 1800s. The Howe School was recently placed on the National Register of Historic Places and has been selected as the future site of the Billerica Museum. (Courtesy of the Billerica Historical Society.)

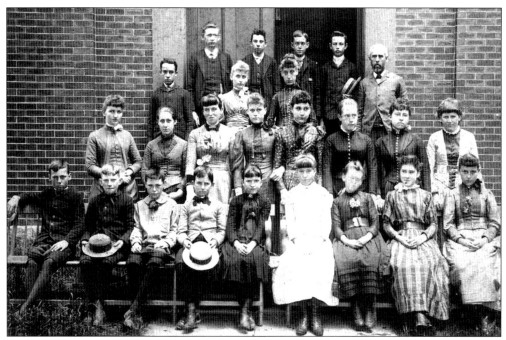

STUDENTS OF THE HOWE SCHOOL. Students and teachers pose on the front steps of the Howe School in the late 1800s. In the background on the right is the headmaster of the school. (Courtesy of the Billerica Historical Society.)

THE INTERIOR OF THE HOWE SCHOOL. Lit by oil lamps, this is one of the two classrooms of the Howe School, shown here c. 1900. The students are largely unidentified, but among them is Lizzie O'Hare, who graduated from the school in 1896. (Courtesy of Helen Knight.)

THE LITTLE RED SCHOOLHOUSE. One of the earliest local schoolhouses, this one stood on Wyman Road and was built c. 1780. With blackboards made of wide boards actually painted black and a small box stove for heat, the primitive building was lit by six windows. (Courtesy of Alec Ingraham.)

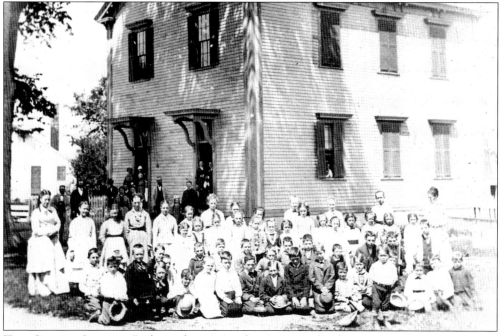

THE CENTER SCHOOL. Built in the 1840s, the Center School, on River Street, is pictured c. 1880 with all of its students and faculty. After a fire c. 1890, the building was remodeled and became the home of the Independent Order of Odd Fellows, who renamed it the Gardner Parker Hall and held meetings there until it burned in 1940. (Courtesy of the Billerica Museum.)

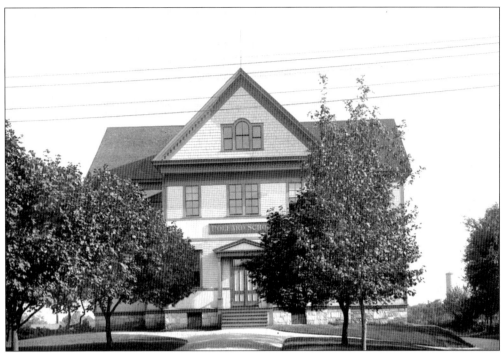

THE POLLARD SCHOOL. The Pollard School was named in honor of Asa Pollard and was located where the Korean War monument stands today on Andover Road. The school was opened in 1892 and was razed *c.* 1981. (Courtesy of the Billerica Museum.)

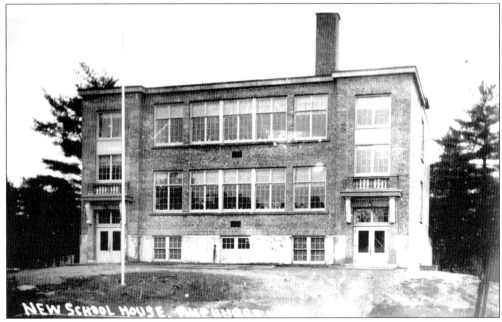

THE DITSON SCHOOL. This brick-and-masonry school is located on Boston Road in Pinehurst. The Ditson Elementary School was named after Revolutionary War patriot Thomas Ditson and was completed and opened *c.* 1931. As the population of the area increased, the school was expanded to the appearance it has today. (Courtesy of Tom Paskiewicz.)

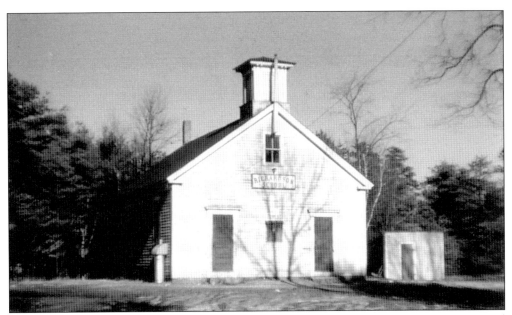

THE RICHARDSON SCHOOL. Built a short distance south of the junction of Route 129 and Andover Road, the Richardson School was constructed *c.* 1850 and served the district until 1935, when it was released by the school department for use as the East Billerica Community Center. It was demolished about 40 years later. The school was originally named after the Richardson family that populated East Billerica. (Courtesy of Kathy Smutek.)

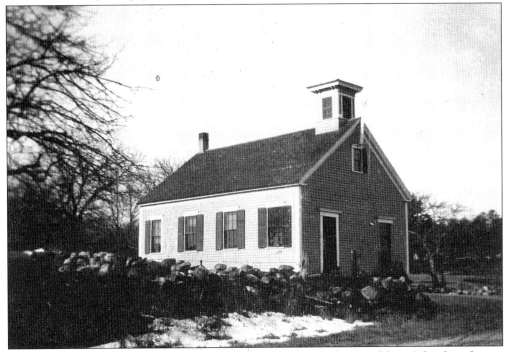

THE SPAULDING SCHOOL. Once located on Nashua Road, the Spaulding School no longer stands. A contemporary of the Richardson School and very similar in appearance, it was constructed *c.* 1845 and razed in the early 1930s. (Courtesy of Charles Kennelly.)

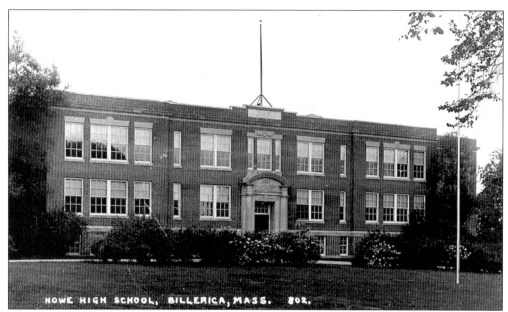

THE HOWE HIGH SCHOOL. As the town outgrew the old Howe School, the only high-school facility in the town, the need for a larger school became apparent. The Howe High School was built in 1915 across the street from its predecessor, and in 1989 it became the Billerica Town Hall. Prior to that date, the building served as a junior high school when the Billerica Memorial High School was opened in September 1955. (Courtesy of Tom Paskiewicz.)

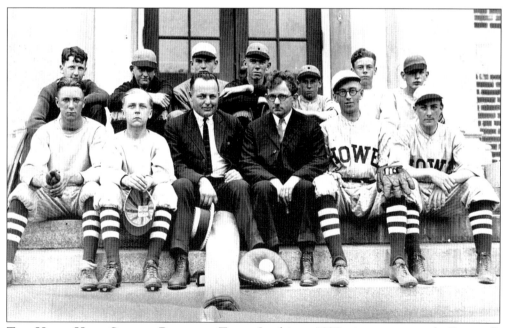

THE HOWE HIGH SCHOOL BASEBALL TEAM. In this c. 1923 view, team coach George S. Gracie Sr. appears in the center with a straw hat in his hand. To the right of Gracie is the principal of Howe High School, Seth Loring. Among the players are Reggie Horman and Arthur Angel. The others are unidentified. (Courtesy of the Gracie family.)

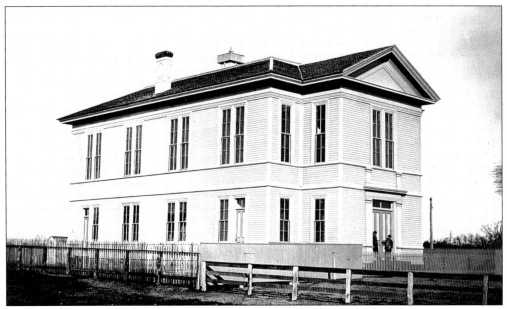

THE UNION SCHOOL. Likely built in 1871, the Union Hall and School stood on what is Station Street in North Billerica, very near the Boston and Maine train depot. It began as a school, served for some time as a town hall and, after a massive fire c. 1890, was completely reconstructed with provisions made for the Billerica Fire Department. The need for firefighting facilities in North Billerica had become evident after successive fires had destroyed the mill complexes. Much of the original building remained unchanged, with the front facade being largely redesigned. The building was razed after the fire station on Lowell Street was completed. (Courtesy of David D'Apice.)

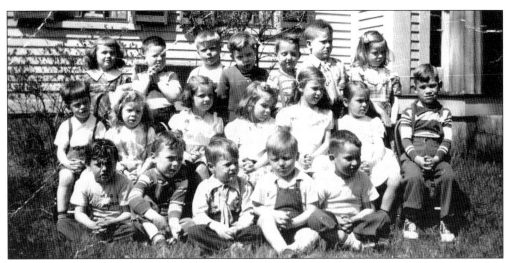

THE FAULKNER KINDERGARTEN. Taken in 1950, this photograph shows the graduating class of the Faulkner Kindergarten, among them Alec Ingraham, itinerant historian. The Faulkner Kindergarten building, still standing on Faulkner Street, was given in memory of James Robbins and Catharine Faulkner in 1903 by their daughters and was extensively remodeled in 1931. The doors opened in 1932. An educational resource for mill children, the kindergarten had begun in 1897 in one of the Faulkner homes at 11 Station Street. (Courtesy of Alec Ingraham.)

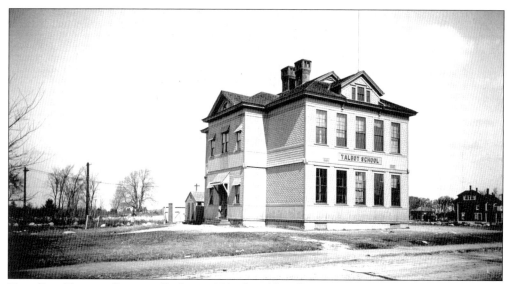

THE OLD TALBOT SCHOOL. Built *c*. 1870, the old Talbot School was the predecessor of the building on Talbot Avenue. Located on the triangle between Wilson and Colson Streets (Talbot Avenue had not been created yet), the edifice was converted to an apartment building, which burned in December 1935. According to newspaper accounts, the school had been built as a single-story building, and a second floor was added as the school-aged population of the village grew. (Courtesy of the Billerica Museum.)

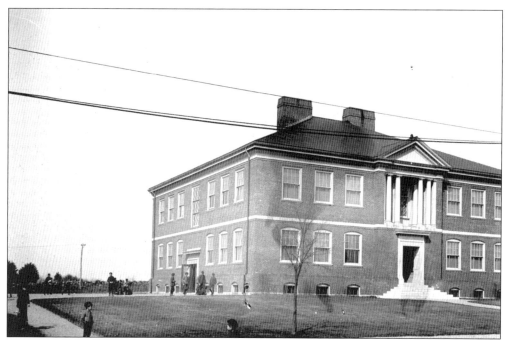

THE NEW TALBOT SCHOOL. Built in 1902 and expanded *c*. 1926, the school on Talbot Avenue is now used by the Billerica Housing Authority. Pictured *c*. 1903 is the recently completed school with children outside at recess. Boys typically played on the left of the building and girls on the right. (Courtesy of the Billerica Museum.)

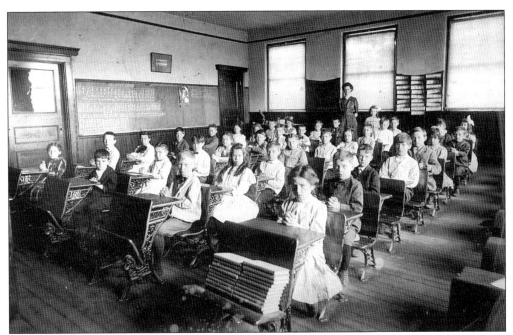

A CLASSROOM IN THE NEW TALBOT SCHOOL. Florence Ruth's class is pictured *c.* 1910. One of the elementary-school grades at the new Talbot School, the class is shown here with music written on the chalkboard. Ruth began teaching a group of 46 students at the school in 1910 and was paid $240 per year. When she married Newell Ritchie (later the postmaster at North Billerica) in 1915, she relinquished her teaching position, as was customary. (Courtesy of Alec Ingraham.)

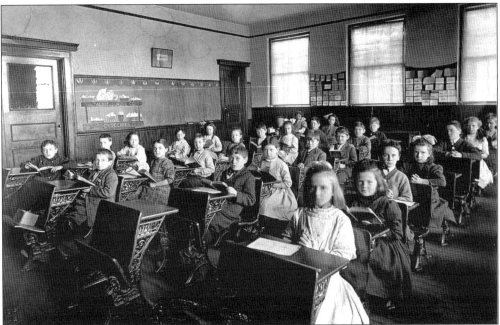

A CLASSROOM IN THE NEW TALBOT SCHOOL. Another group of students at the Talbot School is shown in this *c.* 1910 view. (Courtesy of Alec Ingraham.)

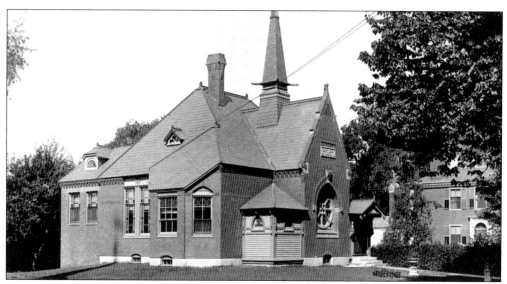

THE BENNETT PUBLIC LIBRARY. Although there had been private libraries in Billerica since the 1700s, the Bennett was the first public library. The gift of Eleanor Bennett in 1880, the distinctive building with its Oriental-influenced spire and stained-glass rose window was one of the most lavishly appointed in the town. The Bennett Library, located on Concord Road in the center, served as the town's library until a larger facility was built in 1979, just four doors south on Concord Road. This photograph shows the library as it appeared at the beginning of the 20th century. (Courtesy of the Billerica Museum.)

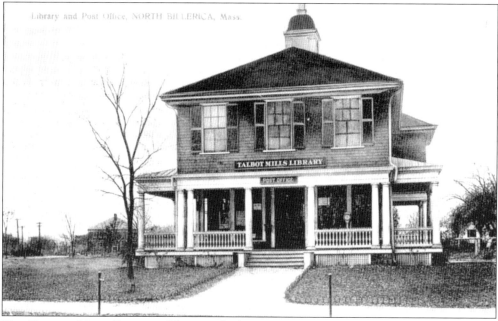

THE TALBOT MILLS LIBRARY. Photographed c. 1908, the Talbot Mills Library stood on Elm Street in North Billerica. In the distance to the left is the new Talbot School, which had been built only a few years earlier. This building served a number of purposes for mill employees and their families. It was a post office, a general store, and a library. It was eventually razed. (Courtesy of Tom Paskiewicz.)

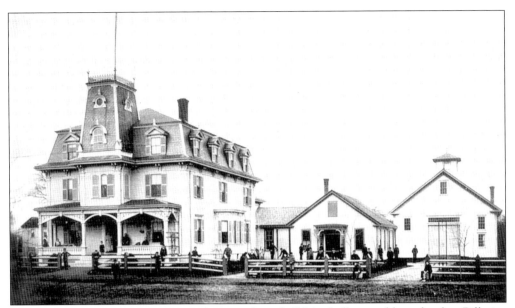

THE MITCHELL BOYS' SCHOOL. Prof. Moses Campbell Mitchell moved his school to Billerica from Edgartown, Massachusetts, in 1879. Located originally on the corner of Boston and Andover Roads on the site of the "old hotel" (which had burned in 1876), the Mitchell Boys' School is pictured as it appeared in 1883. (Courtesy of Alec Ingraham.)

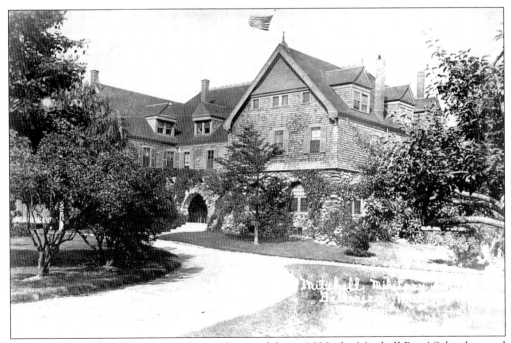

THE MITCHELL BOYS' SCHOOL. After a substantial fire c. 1890, the Mitchell Boys' School moved to new facilities on Concord Road. Shown here c. 1910, the prestigious military academy's main hall and gymnasium were destroyed by fire in 1935. (Courtesy of David D'Apice.)

THE JUNIORS HOME. The Mitchell Boys' School offered horsemanship, military training, and general education. Students came from all over New England and stayed in dormitory housing, such as the Juniors Home, pictured *c.* 1920. (Courtesy of the Freeling McDewell Collection.)

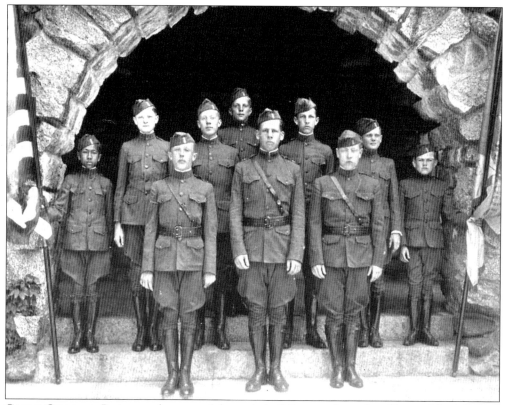

CADET OFFICERS. Posing on the steps of the main building are the cadet officers of the Mitchell Boys' School. This photograph was taken in 1922. (Courtesy of David D'Apice.)

Seven

CHURCHES

UNITARIAN CHURCH COMMUNION SILVER. A priceless collection of Colonial-era silver, this group of 12 pieces is among the finest known in New England. The collection includes the following pieces: a tankard by Williams Homes (1717–1782); a child's cup (initialed "AJ" for Abbie Jaquith, 1836–1919); a caudle cup by John Noyes (1674–1749); a cann by "DP" (likely Daniel Parker, 1726–1785); a tankard (dated 1803) by Samuel Waters; a flagon by Lewis Cary (1798–1834); a two-handled cup by Joseph Foster (1760–1839); a christening bowl (dated 1809) by Joseph Foster; a flagon by Lewis Cary (1798–1834); a pewter plate by Townsend and Compton, London; a two-handled cup by Joseph Foster; and a pewter plate by Townsend and Compton, London. The collection is on loan to the Museum of Fine Arts in Boston. (Courtesy of the First Parish Church of Billerica.)

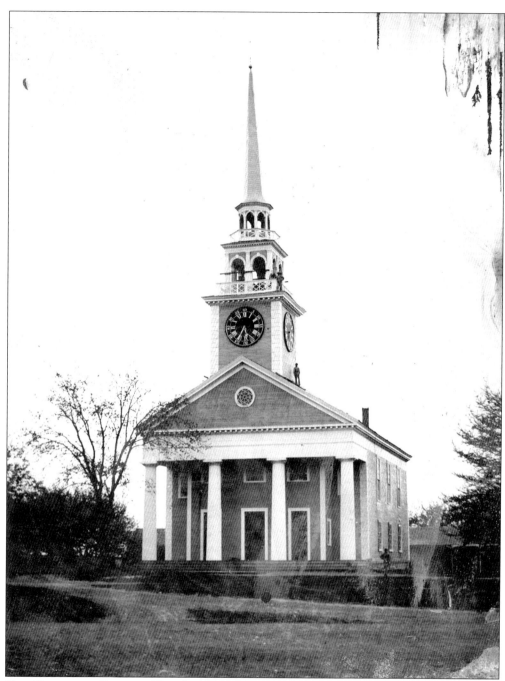

THE UNITARIAN CHURCH. The church is pictured in a tintype made just after the Civil War. The congregation was created as early as 1658, when Rev. Samuel Whiting Jr. accepted Billerica's invitation to become its minister. Built in 1797, the building originally faced north until it was rotated on a cannonball to face the common in 1844. The pulpit was purchased from the Second Church of Boston, which was being demolished. At one time, Ralph Waldo Emerson had preached from it during his ministry there. The bell was cast in 1844 by Hooper, successor to Paul Revere. (Courtesy of the Billerica Historical Society.)

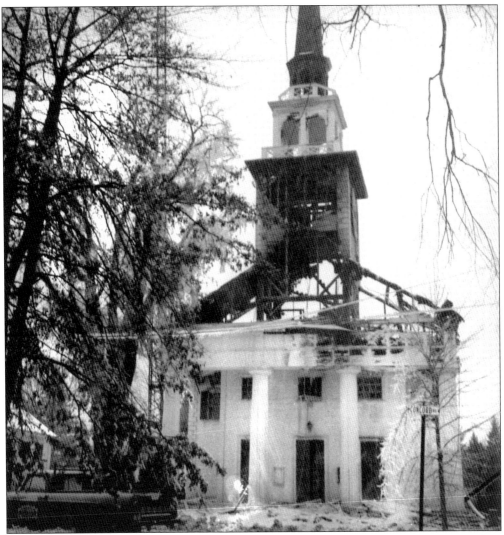

THE UNITARIAN CHURCH. A blaze nearly leveled the church in 1968. In minutes, the fire had consumed most of the interior, the roof, and much of the front. Miraculously, the Ralph Waldo Emerson pulpit survived intact. The church was rebuilt to near original specifications and proudly graces the common once again. (Courtesy of Ann Nicholson.)

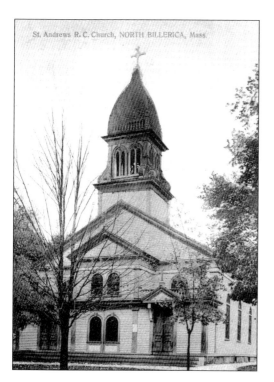

ST. ANDREW'S CHURCH. The Universalist Society, whose membership was composed of dissenting parishioners from the First Parish Church, built this place of worship on River Street in 1842. Within 26 years, the majority of parishioners had returned to the First Parish. In 1868, with the assistance of Thomas Talbot, president of the Talbot Mills, the church was moved to a site on Rogers Street, just north of Call Street. That year, the first Roman Catholic church in Billerica was established. The church served as St. Andrew's parish for over 50 years, allowing Catholic mill workers to worship conveniently. The building is no longer extant, having been sold to be used as a box factory and having been consumed in a devastating fire. (Courtesy of Kathy Smutek.)

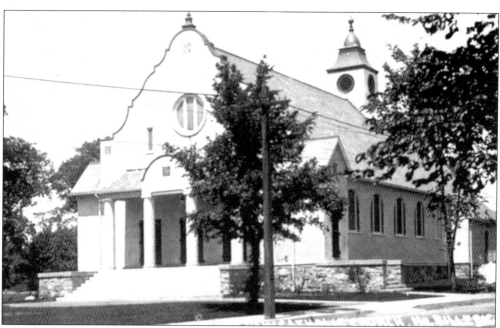

ST. ANDREW'S CHURCH. At the junction of Talbot Avenue, Treble Cove Road, and Colson, Wilson and Pollard Streets, St. Andrew's Church is pictured as it appeared just after its construction, which began in 1919. The building was dedicated on October 16, 1921. (Courtesy of Tom Paskiewicz.)

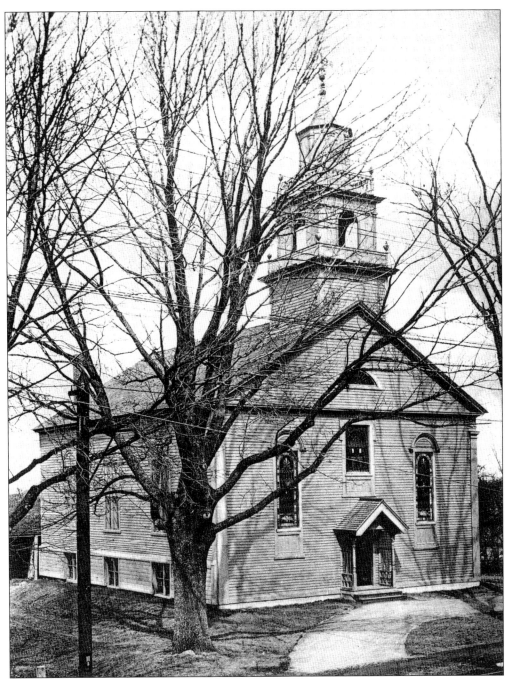

THE ORTHODOX CONGREGATIONAL CHURCH. In 1820, Huldah Blake and Martha Bowers entered a protest about the religious doctrines of the Unitarian church, requesting dismissal. As a long-range result, the Orthodox Congregational Church was established in 1829. The building, located on Andover Road, was dedicated on January 13, 1830, under the leadership of pastor John Starkweather. In 1843, the parish was served by the highly regarded Rev. Jesse G.D. Stearns, who held the office for 20 years. Opening with just 25 members, the congregation has grown and prospered substantially, and the building remains standing today. (Courtesy of Kathy Smutek.)

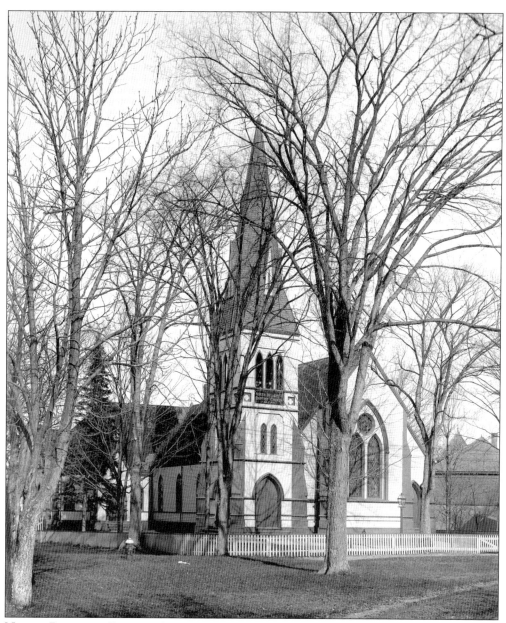

NORTH BILLERICA BAPTIST CHURCH. In 1870, Thomas Talbot built this church at his own expense and presented it as a gift to the Baptist Society, having found that this denomination had the most representatives among his employees and the people of North Billerica. Always practical, he also left a legacy to assist in the church's upkeep. The church was organized in 1869, and the first minister was Rev. William M. Ross. In December 1940, the steeple was struck by lightning and burned. Although the sanctuary was unharmed, the replaced spire has a different design today. The church stands on Elm Street, near the junction of Colson Street. (Courtesy of the Billerica Museum.)

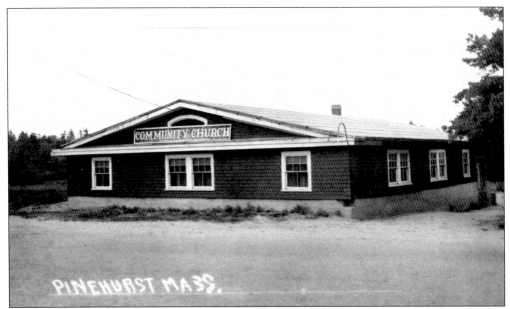

COMMUNITY CONGREGATIONAL CHURCH. Located in Pinehurst on Boston Road, the Community congregation was organized as early as 1916 under the leadership of Rev. J. Harold Dale. It was not until 1923 that the church was incorporated (with Rev. M.H. Sweet as pastor) and a suitable meetinghouse was built. This building served the community until 1948, when it was razed and replaced by a larger church. (Courtesy of Tom Paskiewicz.)

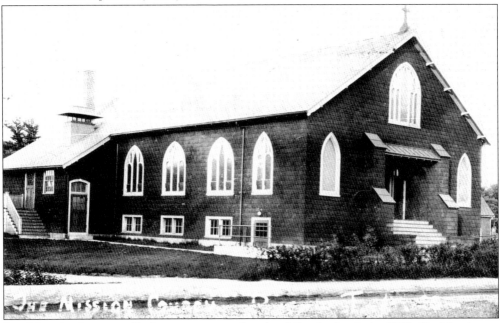

ST. MARY'S CHURCH. Built as a mission church of St. Andrew's in 1928, St. Mary's was completed after some delay in 1936, and Fr. Frederick Muldoon celebrated the first mass on April 12, 1936. On September 29, 1937, the church became its own parish dedicated to St. Mary, and Fr. Charles Johnson became the pastor. The church still stands on the corner of Boston Road and Beaumont Avenue in Pinehurst. (Courtesy of Joseph Shaw.)

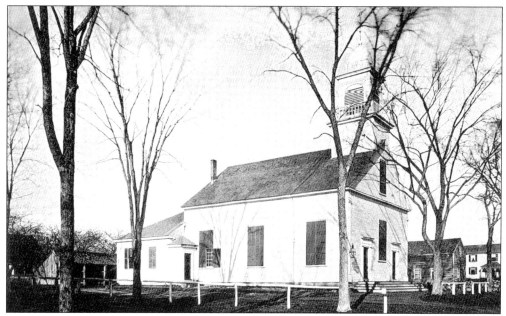

THE BAPTIST AND ST. THERESA'S CHURCH. The Baptists organized in a schoolhouse near the Fordway as early as 1828. Shown here *c.* 1880, their first church building was originally located on the east side of the Concord River near the middle bridge. The building was removed to its present location in 1844 by a team of 120 oxen. A bell was procured in 1872, and a chapel was added in 1877. A decline in parish membership led to the sale of the building in 1923 to the Billerica Grange, which sold it to the Boston archdiocese in 1939. At that time, the building became the mission home of St. Theresa's Catholic Church. A parish was established in 1945, and the building remained in use until a new St. Theresa's was built *c.* 1959. Located on Concord Road near the common, it is now a private residential property. (Courtesy of Charles Kennelly.)

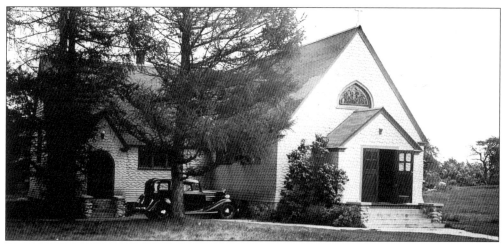

ST. ANN'S EPISCOPAL CHURCH. Located on Treble Cove Road in North Billerica, St. Ann's Episcopal Church was organized by parishioners of St. Ann's in Lowell. Beginning in 1879, two small groups were formed as guilds for women and men. The groups met in prayer in private homes until the church opened in 1890. The church remained a mission church until 1959, when Rev. Stephen Austil became the first rector. (Courtesy of Kathy Smutek.)

Eight

RECREATION

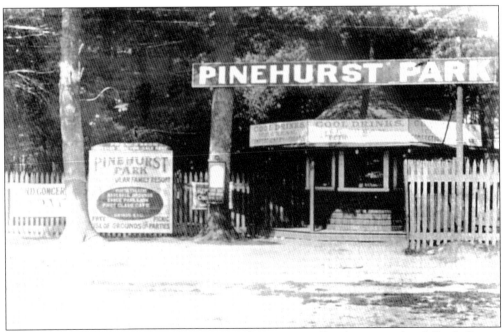

THE PINEHURST PARK ENTRANCE. Located on Boston Road just north of Cook Street, Pinehurst Park was built by the Lowell and Boston Street Railway and was one of the more popular trolley stops. With more than 20 acres of scenic woodlands dotted with swing sets, an outdoor bowling alley, refreshment concessions, and natural wonders, Pinehurst Park opened in September 1901 and continued until the hurricane of 1938 severely damaged it. Pictured is the grand entrance with ticket kiosk. (Courtesy of Jan Wetzel.)

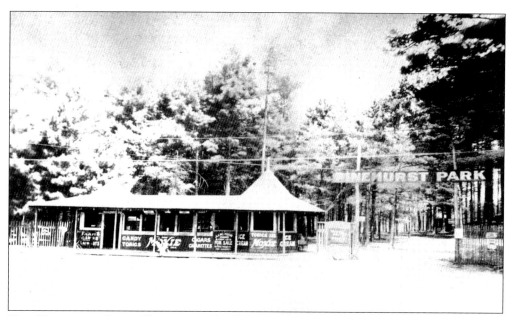

THE PINEHURST PARK ENTRANCE. Pinehurst Park was known for its concerts, theater performances, and dance pavilion. The grounds were available for picnics and parties at no charge, and the trolley fare from Woburn through Burlington to Pinehurst Park was 5¢. This c. 1918 photograph shows the expanded ticket kiosk, used as a trolley platform for passengers to arrive and depart from the park. (Courtesy of Joseph Shaw.)

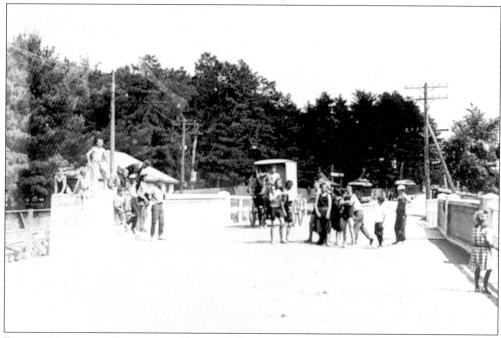

ROUTE 3A AT THE SHAWSHEEN BRIDGE. This summertime view of Boston Road dates from c. 1919 and shows a group of children and tourists. On the left are the trolley tracks that cross the Shawsheen River Bridge, and in the distance behind the horse and wagon, the trolleys are making the stop in front of Pinehurst Park. (Courtesy of David D'Apice.)

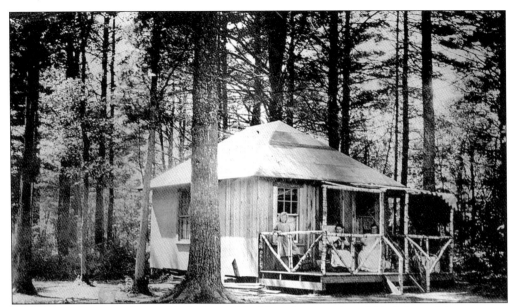

PINEHURST SUMMER CAMP. Crafted *c.* 1915 of found materials and birch logs, this camp cost a total of $348 to build, including $98 for the land. With $5 down and $5 per month payments, camp owner Dorothy Sand had planned to build additions to it as she could afford them. (Courtesy of the Billerica Historical Society.)

LILLIAN RUSSELL AND LEGHORN CHICKEN. Working for the Lowell Cartridge Company at a weekly salary of $9, Lillian Russell purchased 12 lots in Pinehurst for $49 each. Her husband was a Civil War veteran and invalid who lived at the Chelsea Hospital. She cleared the land herself, built a number of small buildings, and supported her aging mother. Her taxes were paid by raising leghorn chickens and a large pig. Mrs. Russell is shown here *c.* 1919 with one of the chickens, outside a rustic cabin she built with her own hands. (Courtesy of the Billerica Historical Society.)

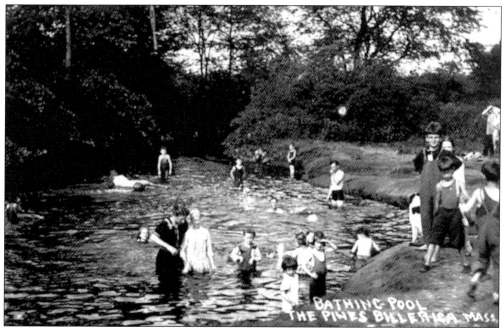

THE PINES BATHING POOL. Located near Cook Street, this *c*. 1920 view features bathers, some of them completely dressed, in a naturally formed bathing pool. (Courtesy of Tom Paskiewicz.)

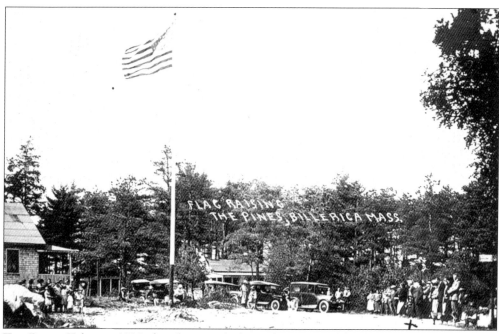

THE PINES. Taken in 1923, this photograph shows the raising of the flag outside just one of the many camp resorts that the Pines, off Cook Street, had to offer. (Courtesy of David D'Apice.)

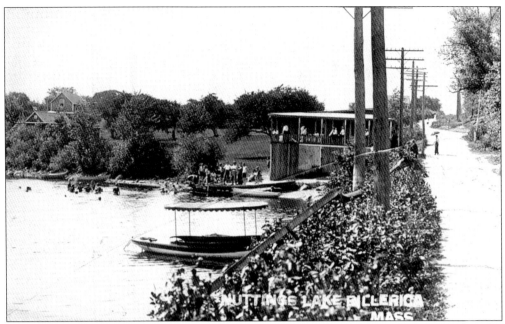

NUTTING'S LAKE. Taken from where the Middlesex Turnpike crosses Nutting's Lake, this *c.* 1910 photograph features the gondola-style boats that could be rented at Dolan's store, in the background. There was a dock for fishing, swimming, and boating, and the store served as the hub of Dolan's real estate speculation business. (Courtesy of David D'Apice.)

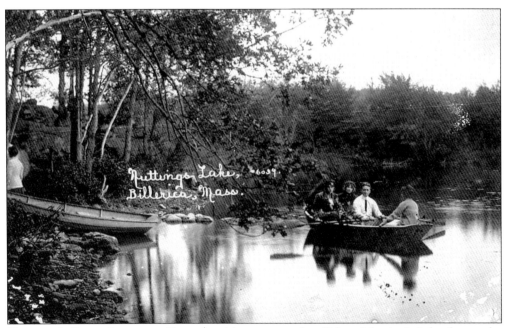

NUTTING'S LAKE BOATERS. Canoes and boats were plentiful on Nutting's Lake due to the seasonal rental market, and here are four young people enjoying an afternoon on the water. Dating from 1920, this image captures the serenity and natural beauty of the setting. (Courtesy of David D'Apice.)

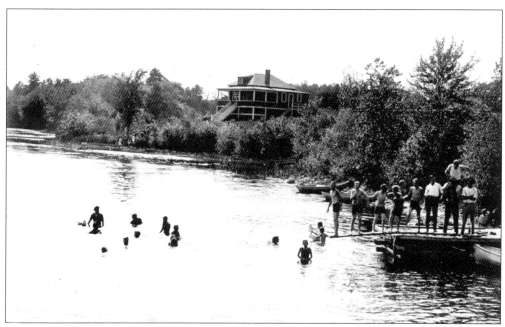

NUTTING'S LAKE SWIMMERS. Young people frolic in the lake waters *c.* 1920. (Courtesy of David D'Apice.)

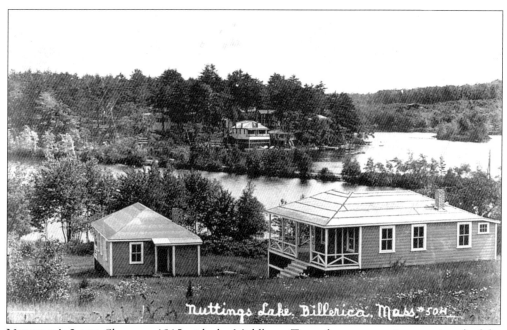

NUTTING'S LAKE. Shown *c.* 1915 with the Middlesex Turnpike causeway intersecting the lake in the background, these two small cottages were a summer retreat for city dwellers. (Courtesy of David D'Apice.)

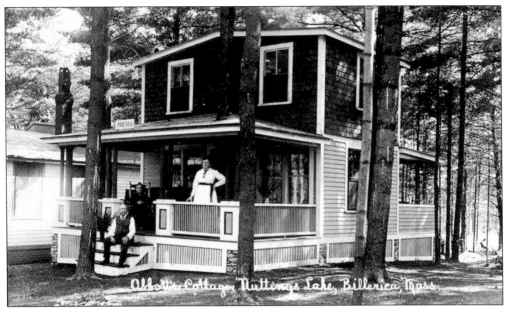

THE ABBOTT COTTAGE. Mr. and Mrs. C.O. Abbott lived in Somerville and enjoyed the summers on Nutting's Lake. They frequently invited friends to stay with them. Pictured on the porch are Mr. and Mrs. Abbott and "mother" seated at the rear. This photograph was taken in 1917. (Courtesy of Tom Paskiewicz.)

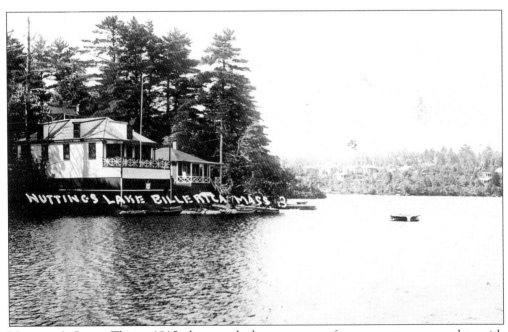

NUTTING'S LAKE. This *c.* 1915 photograph shows a group of serene cottages, complete with small docks for boating or fishing, on the south side of the lake. (Courtesy of the Freeling McDewell Collection.)

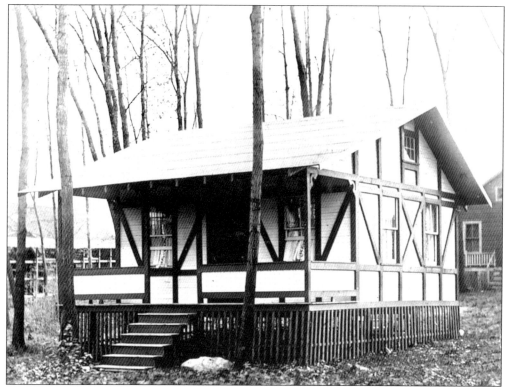

A NUTTING'S LAKE CAMP. This photograph shows one of the summer camps *c.* 1921 at Nutting's Lake. The camps were available for as little as $150 down and $10 per month, and the realtor's office was open every day but Friday. (Courtesy of Tom Paskiewicz.)

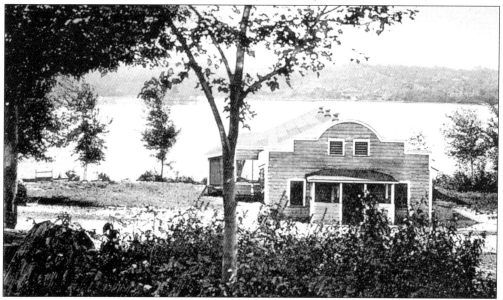

THE NUTTING'S LAKE DANCE HALL. Known to people from areas around metropolitan Boston, Nutting's Lake had a dance hall that featured live entertainment. This photograph shows the hall as it appeared on the shore of the lake in 1926. (Courtesy of Tom Paskiewicz.)

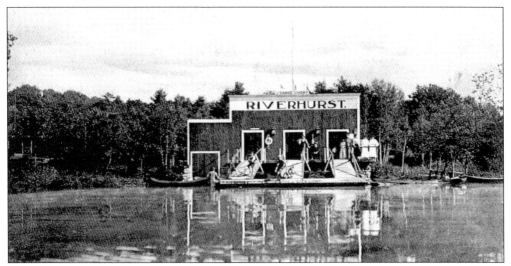

THE RIVERHURST BOATHOUSE. Located just off Concord Road on the Concord River, this boathouse was so popular that it was substantially enlarged. The building is shown before the addition, when it was still a fairly small-scale operation. The boathouse was built sometime before 1912. (Courtesy of Tom Paskiewicz.)

THE RIVERHURST ENTRANCE. This undated photograph shows the entrance to Riverhurst, off Concord Road, where the boathouse and riverfront swimming were located. The site is presumably near where Riverhurst Road is today. (Courtesy of Tom Paskiewicz.)

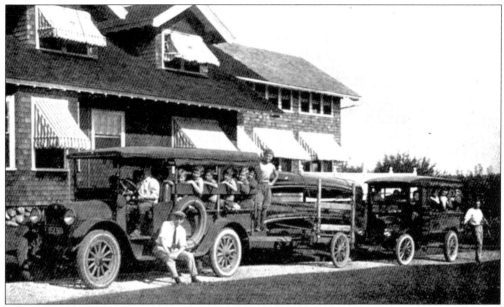

CAMP SKYLARK. In the summers, the Mitchell Boys' School offered Camp Skylark, a season of healthful fun that ran from July through August. The main focus of the camp was horsemanship for boys, and campers came from all over New England to attend. This 1929 photograph shows a group of adventurers out for a day trip of bathing and canoeing. (Courtesy of David D'Apice.)

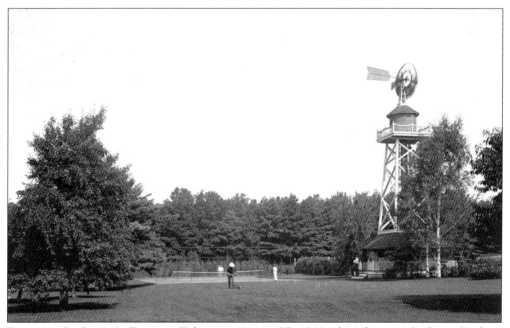

FREDERIC S. CLARK'S ESTATE. Taken on August 27, 1903, this photograph shows Frederic Clark's recreational park, used by his family and friends. The estate was located on Mount Pleasant Street in North Billerica. He was, at various times, president, superintendent, and treasurer of the Talbot Mills. Pictured are the tennis court and the windmill that provided water for the estate. A croquet game is set up on the lawn. (Courtesy of the Billerica Museum.)

Nine

PORTRAITS

HENRY CUMINGS. Born in Dunstable on September 16, 1739, Rev. Henry Cumings graduated from Harvard College in 1760. He had studied theology with Daniel Emerson of Hollis and was ordained minister of the Unitarian church in Billerica on January 26, 1763. His home was later the Clara Sexton house on Concord Road, and he died in office on September 5, 1823, at the age of 83. Many of Reverend Cumings's sermons have been preserved at the Billerica Historical Society's home on Concord Road. A man of the people, he was known for helping shape the course of town history, especially during the American Revolution. He was buried in the South Cemetery on Concord Road under the only table stone in Billerica. This portrait was the gift of Rebecca Wilkins Warren. (Courtesy of the Billerica Historical Society.)

MARSHALL PRESTON. The son of one of the longest-lived survivors of the Revolutionary War, Marshall Preston was born in Bedford on June 5, 1792. He practiced law in Billerica until 1849, when he moved to Lexington with his aging father. He held a number of offices in Billerica, among them town clerk, postmaster, assistant clerk of courts of Middlesex County, and trustee of the Zadok Howe estate. Marshall Preston's Greek Revival home still stands on Boston Road. It was sold to William Blanchard and subsequently to Luther Faulkner, who in turn helped it become the Unitarian parsonage. (Courtesy of Margaret Ingraham.)

A. WARREN STEARNS. There has always been a Stearns in Billerica, ever since John Sternes arrived here in 1653 and the town was called Shawshin. Dr. A. Warren Stearns was born in 1885, a member of the 10th generation of the Stearns family. He received his medical degree from Tufts College, eventually becoming the commissioner of corrections for Massachusetts. He is credited with the idea of using the Billerica House of Correction as a functioning farm, building skills and a prison workforce. A selectman and school committee member, he was also president of the Billerica Historical Society for 45 years. He died in 1959. Much of the town's history has been preserved through the efforts of Dr. Stearns and his son, Dr. Charles Stearns.

ZADOK HOWE. Dr. Zadok Howe was born in Bolton, Tolland County, Connecticut, on February 15, 1777. At the age of 16, he learned watchmaking and shortly afterward became an "artist of sorts." He subsequently developed an interest in medicine, and in 1809, he received a medical degree from Dartmouth College. He practiced in several locations before coming to Billerica in 1816, where he achieved immediate popularity. A member of the Massachusetts Medical Society, he was noted for his surgery and is said to have made his own instruments. Howe died at his home on the corner of Andover and Boston Roads on March 8, 1851, leaving most of his estate for the creation of an academy of higher learning in Billerica. He appointed a board of trustees to oversee the construction of the school that bears his name. The Greek Revival building was built the following year and still stands on Boston Road opposite today's town hall. Dr. Howe is buried in the South Cemetery. (Courtesy of Alec Ingraham.)

HARRIETT BURBANK ROGERS. Born in North Billerica in 1834, Harriett Rogers was America's pioneer teacher of the profoundly deaf. Director of the Clarke School for the Deaf in Northampton, she was known for her revolutionary methods of teaching, which brought greater opportunity to thousands of deaf people. She retired to her old home in Billerica and died in 1919. In their old age, she is pictured on the left with her sister Elvira Rogers Gould. (Courtesy of the Billerica Historical Society.)

JAMES ROBBINS FAULKNER. The son of mill entrepreneur Francis Faulkner, James Robbins Faulkner was born on April 14, 1801, in North Billerica. James continued the manufacturing of wools and flannels in North Billerica when his father died in 1843. His mill, part of which now houses the Middlesex Canal Association Museum, still stands today on Faulkner Street. James Robbins Faulkner was also an influential and notable citizen of the town and a trustee and treasurer of the Howe School. (Courtesy of the Billerica Historical Society.)

CATHARINE ROGERS FAULKNER. Married to James Robbins Faulkner on November 22, 1825, Catharine Rogers Faulkner (born on July 29, 1804) was the daughter of Josiah Rogers of North Billerica. (Courtesy of the Billerica Historical Society.)

LUTHER WINTHROP FAULKNER. A younger brother of James Robbins Faulkner and son of Francis Faulkner, Luther Winthrop Faulkner was born in North Billerica on April 2, 1815. He began his own mills in Fisherville, New Hampshire, and South Lowell and sold out to the American Woolen Company in 1898. He died in 1904 at his home on the corner of Andover and Boston Roads in the center. (Courtesy of Margaret Ingraham.)

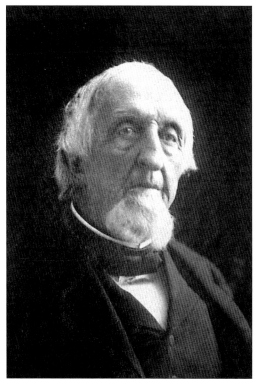

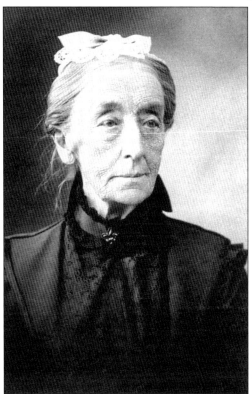

MARTHA MERRIAM FAULKNER. Married to Luther Winthrop Faulkner in 1842, Martha Merriam Faulkner had eight children with her husband. She enjoyed cultivating roses, as well as oil painting and decorating. A strong supporter of the Billerica Historical Society and a patron of the Bennett Library, Martha Faulkner left a number of time capsules in the form of letters and bottles sealed in walls at locations around the center of town. She died in 1905 after a sudden illness. For 50 years, she lived in the home that had previously been occupied by Dr. Zadok Howe. (Courtesy of Margaret Ingraham.)

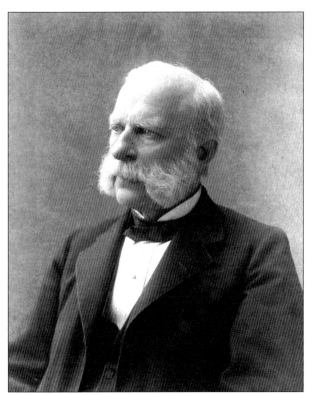

THOMAS TALBOT. Born in Cambridge, New York, on September 17, 1818, Thomas Talbot was the son and grandson of a family of broadcloth manufacturers. When his mother became a widow in 1823, financial hardship fell upon the family. In 1830, at the age of 12, Thomas began working for a woolen mill in Northampton. In 1839, he came to Billerica and formed a partnership with his older brother, Charles Talbot, for the grinding of dyewoods. By 1849, the firm had become the Talbot Dyewood and Chemical Company. The woolen mill was built in 1857. Thomas was elected governor of Massachusetts in 1878. He died on October 6, 1886, after an 18-day illness. (Courtesy of Margaret Ingraham.)

CLARA ELIZABETH SEXTON. Born in Billerica in 1857, Clara Sexton was active in town affairs and social groups. Her particular interest lay in the preservation of Billerica's past, from homespun cloth to antique sleighs. Although the trustees of the Bennett Library had graciously provided space for the Billerica Historical Society to accumulate treasures from the town's past, the collection soon outgrew the offering. In 1936, when Sexton died, her will stipulated that the Billerica Historical Society should become the recipient of her house, once the home of Rev. Henry Cumings, at 36 Concord Road. Her wish to preserve Billerica's past is honored there to this day, and the house has become an historical keystone of the community. (Courtesy of the Billerica Historical Society.)

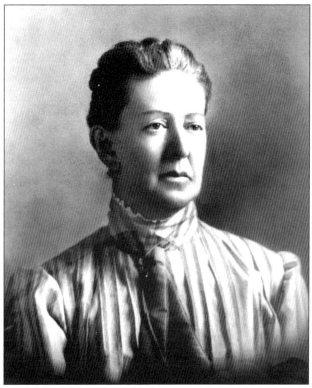